	•				

PRACTICAL WATERCOLOR PAINTING

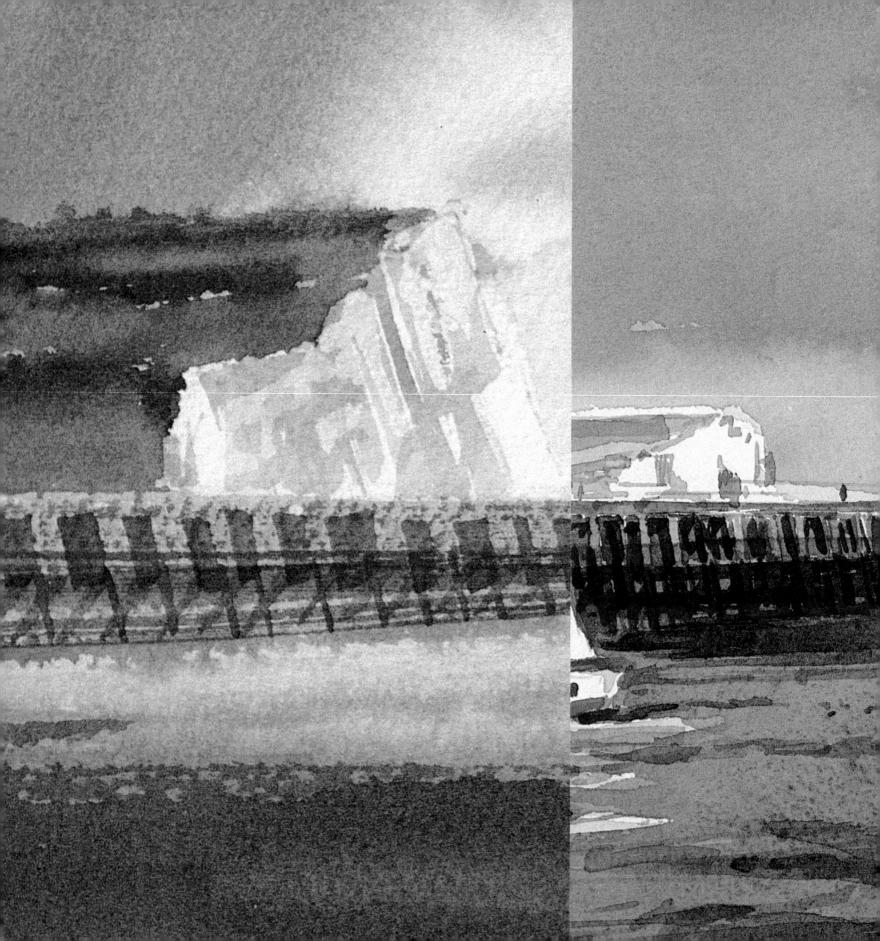

The Comprehensive Guide to Materials and Techniques

BY GERALD WOODS

751, 422 Woo C1

Copyright © 1995 CLB Publishing

This edition first published in the United States by Courage Books, an imprint of Running Press Book Publishers.

All rights reserved. This book may not be reproduced in whole or in part in any form or by any means, electronic or mechanical, including photocopying, recording, or by any information storage and retrieval system now known or hereafter invented, without written permission from the publisher and copyright holders.

CLB 4070

987654321

Digit on the right indicates the number of this printing.

Library of Congress Cataloging-in-Publication Number 94-74908

ISBN 1-56138-595-6

This book was designed and created by The Bridgewater Book Company Limited and produced by CLB Publishing, Godalming, Surrey, England
Designers Peter Bridgewater / Annie Moss
Editor Viv Croot
Managing Editor Anna Clarkson
Photographer Jeremy Thomas
Typesetters Vanessa Good / Kirsty Wall

Printed and bound in Spain

Published by Courage Books, an imprint of Running Press Book Publishers 125 South Twenty-second Street Philadelphia, Pennysylvania 19103–4399 3/96

Contents

INTRODUCTION

page 8

PART ONE • MATERIALS AND TECHNIQUES

page 10

PART TWO . THE PROJECTS

page 56

Introduction

Victorian ladies, watercolor painting is now generally regarded as a medium capable of serious artistic expression. For many people the whole activity of painting in watercolor is a process that is analogous to nature itself. The layering of translucent washes over one another is akin to the order of natural growth. Unconsciously perhaps, many artists working in watercolor are attempting to produce paintings that can be enjoyed in the way that one enjoys real fields, trees and meadows. The love of landscape is one of the most deeply felt of human sentiments and this, in part, accounts for the renewed interest in watercolor.

Watercolor is an ideal medium for recording the many moods and momentary effects of light in landscape, as J.M.W. Turner demonstrated so magnificently in his studies of mountains, lakes and rivers. Of course, one need not be confined to landscape as a subject – as is evident in the range of themes and examples in the Project Section of this book.

The artist is always in a learning situation—after a lifetime of painting landscapes from direct observation, Paul Cézanne confided to his friend Emile Zola, "rather late—I have begun to see nature." We learn from artists like Cézanne, we learn from different cultures, from different periods of art history and, when a group of like-minded individuals work together in an art class, they learn from one another.

In this book you will see how three different artists using watercolor interpret the same subject.

An artist never paints things as they are, but as he or she sees them – and this, essentially, is what distinguishes the work of one artist

from another. Because the exact reproduction of nature is an impossible pursuit, we tend to extract or select different things from whatever view confronts us. You will see, for instance, how the artists in this book work from the same still life but nevertheless interpret it quite differently. While one artist might be primarily concerned with the compositional relationship between objects, another might be more interested in color, texture and tonal value. But at the end of a painting session, each can compare his or her interpretation with that of other people in the group and, inevitably, understanding of the subject is enhanced by the very differences of interpretation and visual expression.

Consciously or unconsciously, we "borrow" ideas from one another. I might, for example, be impressed by the way in which another artist "handles" or applies color or by the particular quality of marks made with a brush or pencil. At one time an essential part of an artist's training was to visit the Louvre, the National Gallery or other such institutions, to make direct copies from master paintings. That is not to suggest that one should not be single-minded – the painter Gwen John, when asked if she admired the work of Cézanne, replied that she did, but that she liked her own work better! The point being that while we are able to learn from each other, we must at the same time try to discover the world in our own terms. Seeing is a search for meaning and understanding; for what matters most to an artist is not the nature of the world itself but the nature of his or her reactions to it.

The whole point of this book, therefore, is not just to help you gain a better understanding of the essential characteristics of the watercolor medium, but also to enable you to use it to say what *you* want to say.

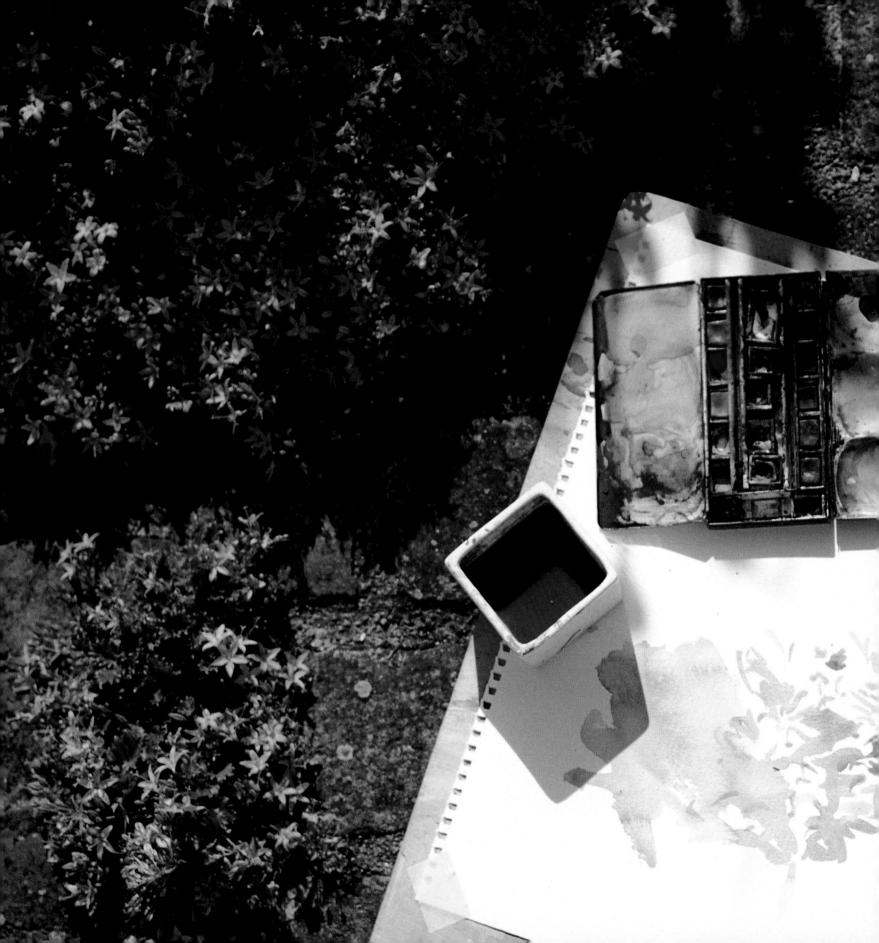

Choosing Materials

Just to see a profusion of artists' materials in an art store can be sufficient inducement to make you want to start painting right away. Row upon row of shining new tubes of color, paintboxes, brushes, sketchbooks and so on all combine to make you feel that, if only you possessed these things, you would be already halfway to being an artist!

But this, of course, is an illusion – watercolor paintings can be produced with a minimum amount of equipment. You can manage perfectly well with a paintbox containing a dozen colors, a few pencils, brushes and paper. What does matters, however, is that the materials you do buy are of the best quality.

Watercolors, in particular, should be bought from an artists' supplier of repute – cheap substitutes usually contain chalk filler and other additives. Try to include at least

one sable brush in your selection. Some of the brushes made from synthetic hair, however, are less expensive and quite good.

There are many watercolor papers to choose from but, in the first instance, avoid buying paper that is heavier than 190 gsm / 90 lb. Heavier papers are very expensive and you would feel inhibited about the possibility of making mistakes.

When working outside, you will want to avoid having to carry too much equipment. In the course of trying to find the right viewpoint for your painting, you may have to walk a considerable distance and climb to different levels. You will feel less inclined to do this if you are weighted down with equipment.

There are a number of lightweight sketching easels made from beechwood or aluminum, which can be folded and are easily carried. However, I would rather invest in a good lightweight folding chair, since to my mind it is just as easy to balance a sketchbook on my knee as to work at an easel.

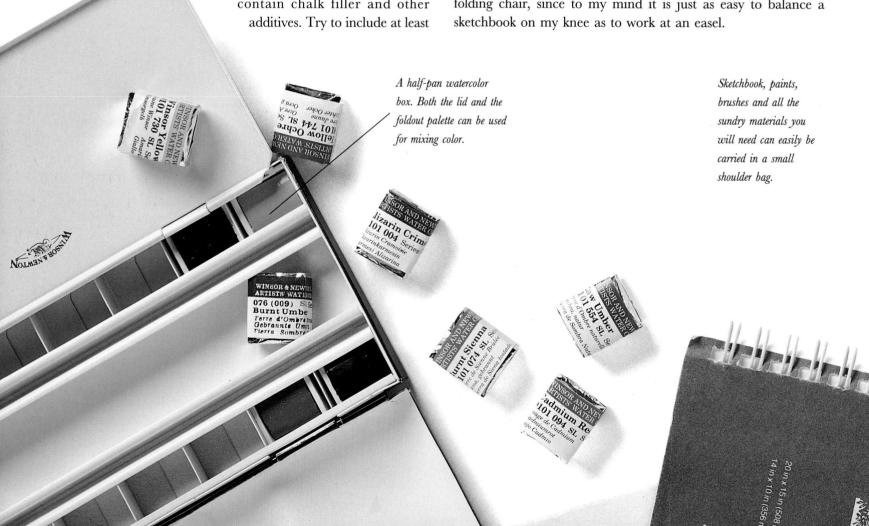

CHOOSING MATEL A selection of sable brushes for broad washes and more detailed work. Ceramic palette. Tubes of watercolor. 538 (328) 8ml e 7 U.S. fl.oz.

A BASIC KIT FOR LANDSCAPE PAINTING

- Sketchbook (preferably spiral-bound); alternatively, sheets of paper clipped to a lightweight board.
- A box of watercolors containing the following colors: Cadmium Yellow, Yellow Ocher, Burnt Sienna, Burnt Umber, Alizarin Crimson, Cadmium Red, Indian Red, Payne's Gray, Cerulean Blue, Ultramarine, Monastral Blue and Lamp Black.
- A ceramic mixing palette (an old saucer or plate will do).
- At least three brushes: a large wash brush No. 20 or a Hake, No. 6 sable for finer work, and a long haired "rigger" for painting lines; a brush holder (see page 25) to carry them in.
- Pencils 2B or 3B and a knife (never use a pencil sharpener), eraser, pen and ink, Chinese White in a tube.
- A lightweight shoulder bag to carry everything in.

Spiral-bound sketchbook.

Bockingford oatmeal 190 gsm / 90 lb (CP)

BACKGROUND
Fabriano Rough
105 gsm / 90 lb

Bockingford cream 190 gsm / 90 lb (CP)

Bockingford eggshell 190 gsm / 90 lb (CP)

Arches blanc
190 gsm / 90 lb (CP)

Paper

sized white paper is the support normally used for watercolor painting. The artist today is faced with a wide choice of papers from the United States, England, France, Italy and Japan.

My own preference is for paper that is not too heavily sized, and without a pronounced "tooth."

Strathmore, Arches, Saunders Waterford, Whatman and Fabriano are all fine papers that bring out the best characteristics of transparent watercolor glazes. In the first instance, however, any white paper that is heavy enough to withstand stretching, washing out and reworking, and does not buckle when wet, is ideal. Inexperienced artists should initially avoid expensive papers with a pronounced "tooth," which might tend to flatter the work, and avoid toned papers for the same reason.

Watercolor papers are classified by weight and surface texture.

- <u>CP</u> (cold-pressed) has a semirough surface of medium grain that accepts washes without too much absorption.
- <u>HP</u> (hot-pressed) papers have a much smoother surface with a fine grain with sufficient texture to retain a wash. It is an ideal paper for working in pencil and wash or for fine brushwork.
- ROUGH paper has a coarse surface, achieved by drying the sheets between rough felts without pressing. This paper is most suited to strong, broadly painted washes. It is generally unsuited to pen and ink or soft pencil, which tends to smudge.

WEIGHT

At one time, the thickness of paper was determined by the weight of a ream (500 sheets) of that particular paper in a given size. Today, however, it is expressed as the weight of a square meter of a single sheet of paper given in grams – gsm. An average weight for a watercolor paper would be about 300 gsm / 140 lb. The heaviest is about 638 gsm / 300 lb.

SIZING

Watercolor papers are generally sized. Unsized papers, known as waterleaf, are generally unsuitable since they absorb the color and tend to "bleed." The "right" side of the paper is determined by the maker's name, which appears as a watermark reading in the right direction when held up to the light.

Bockingford 300gsm / 140lb (HP)

Saunders Waterford 300gsm / 140lb (HP)

Fabriano Artistico 300gsm / 140lb (HP)

Fabriano Rough Artistico 190gsm / 90lb (CP)

Watercolor papers are usually sold as loose sheets, spiral or edge-bound pads, or in block form.

Bockingford white 535 gsm / 250 lb (CP)

Sketchbooks

small pocket-sized books to larger, more unwieldy sizes.

Constable was in the habit of using very small pocket sketch-books that he always carried with him ready to draw anything that beckoned his attention. Bonnard, too, produced some of his most intimate drawings on the pages of an old diary. In a sense, a sketchbook is a visual diary in which one records everyday observations. Many sketchbooks conform to standard writing-paper sizes.

The quality of the paper varies from an inexpensive machinemade cartridge to heavier weights of mold-made watercolor paper. It is now possible to buy a range of tinted Bockingford papers in the form of a spiral-bound sketchbook.

Alternatively, you may prefer to select a range of different papers and have them bound by a bookbinder. One advantage of doing this is that the paper can be cut to a proportion of your own choosing. It is rare, for instance, to find a sketchbook that is square in proportion.

More economically, you can simply sandwich a variety of papers between two stout sheets of cardboard or millboard, held togeth-

A property of the state of the

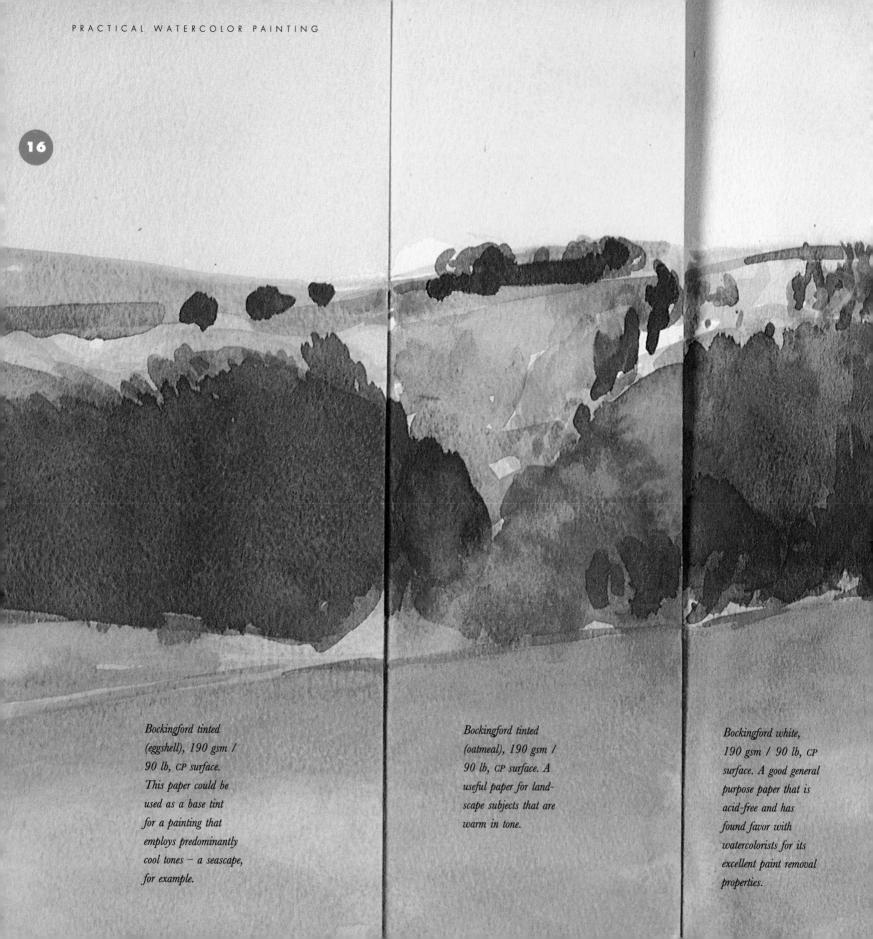

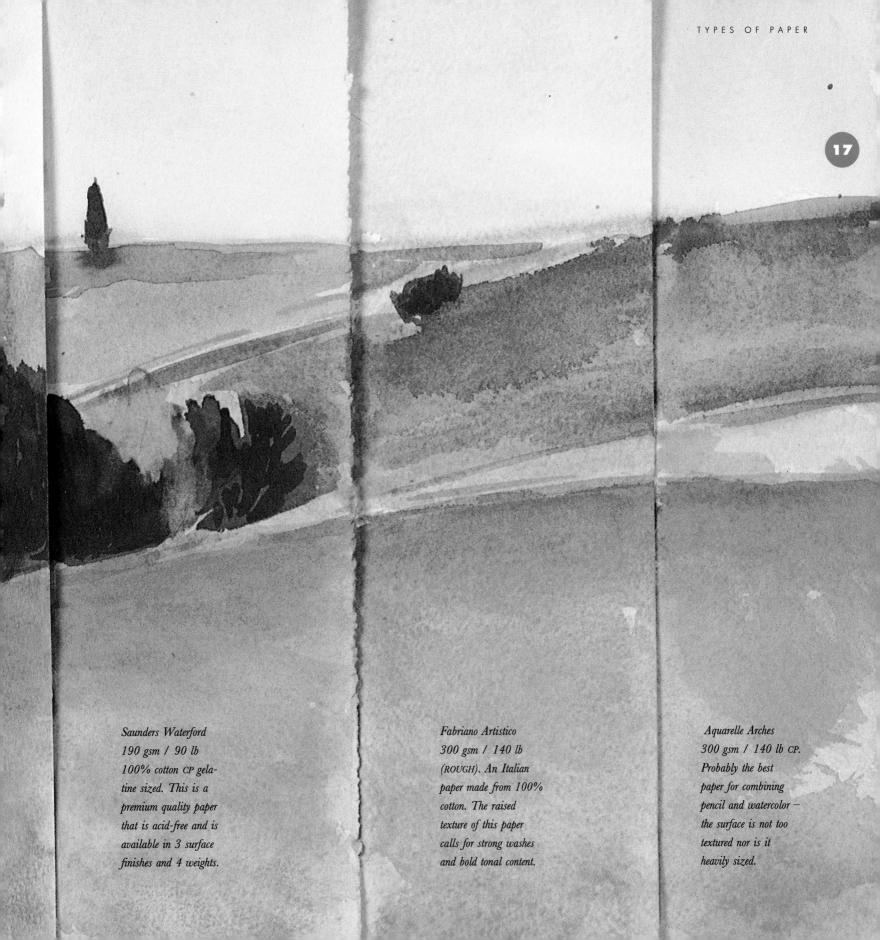

n the manufacture of watercolors the pigment is first separated into individual particles. Gum arabic, which comes from the acacia tree, is one of the most important additives, since it binds the pigment together and is also water-soluble. Because most pigments do not blend easily into aqueous solutions, other wetting agents are required, such as oxgall, and detergents to aid the process of dispersion. Sugar and glycerine are also added to prevent the colors from drying out completely.

Most manufacturers have jealously guarded their recipes and only one has been prepared to publish his formulae. The London supplier Robert Ackermann was able not only to offer sixty-eight prepared watercolors for sale in 1801, but also published the recipe for those who wished to prepare their own colors. Ackermann's recipe involved four separate stages of manufacture and included gum arabic, sugar candy, distilled water, honey and distilled vinegar in varying proportions. But he warned those who wanted to prepare their own colors that, "the time, the trouble, the expense of attending their preparation will never compensate the small saving gained by it."

Watercolors are usually bought as a preselected range of colors in the form of semimoist cakes or pans, contained in a metal

744 (059) SL Series 1 ;

Yellow Ochre Ocre Jaune Lichter Ocker Ocre Amarillo box. The compartmentalized lid of the box acts as a mixing palette when the box is opened out flat. Half-pans are small cakes of color held in a plastic container

3/4 inch square. You

WINSOR AND NEWTON ARTISTS WATER COLOUR

Winsor Blue 0100 706 SL Series 1 A may, however, prefer to buy an empty color box and select your own colors – in which case, you can mix half-pans with full-pans of color. The full-pans are likely to be colors you will use most frequently – blues, yellows and reds – while your half-pans might be restricted to colors that are used sparingly, such as violet, Lamp Black or crimson.

Some artists prefer the convenience of having tubes of watercolor or bottles of liquid watercolor. Much

Tubes contain watercolor pigment in a more liquid form. The texture of the paint is generally more consistent than pan colors.

depends on the kind of work you are doing. If, for example, you are painting a landscape, then you might want to be able to see all your colors at a single glance without having to squeeze them out of individual tubes. On the other hand, you might consider it an advantage to be able to squeeze out just enough color for your purpose.

When selecting your own colors, you will no doubt add some of the more unusual hues to the basic set of primary, secondary and tertiary colors. You might also be guided in your choice of palette by the colors used by the great watercolorists. Turner, for instance, used several Chrome Yellows, Cobalt Blue, Indian Red, Madder, Yellow Ocher, Vermilion, Venetian Red and Raw Sienna.

A selection of half- and full-pan watercolors.

You will need full pans for the colors used most frequently.

course, in itself turn you into a good colorist - but it can be a contributing factor. It is important to choose watercolors of a good quality. Poor-quality watercolors usually contain too much white filler. You will only be able to reproduce rich, granular washes by using artists' quality paints.

Most manufacturers offer some guidance as to the permanence or fugitiveness of their colors. Alizarin Green is fugitive, and Prussian Blue is liable to fade. Vermilion darkens in bright light, and colors with a dye content, such as Alizarin Crimson, are difficult to remove.

The choice of colors will not, of

You will discover that certain colors are better used in small patches than as large flat washes. Colors such as French Ultramarine, for instance, tend to granulate either alone or when mixed with other colors. The behavior of different pigments will become more apparent with practice. Certain effects achieved by mixing color may be unexpected and can either enhance a painting or ruin it altogether.

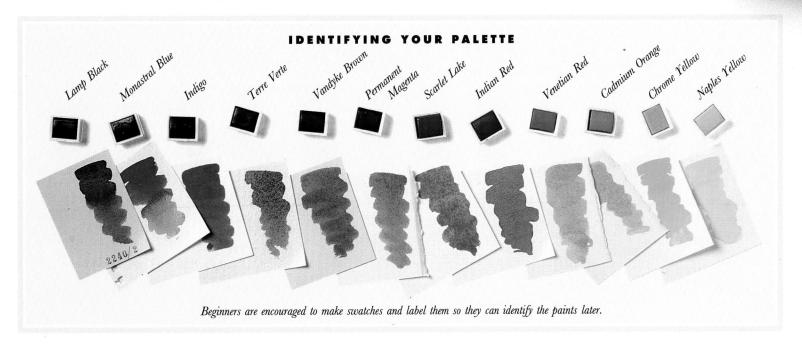

PRACTICAL WATERCOL Media he quality of a Transparent colored inks can be watercolor successfully combined with watercolor. painting can be enriched by combining various techniques and materials. Colored inks, for instance, produce transparent glazes that are entirely different in character from a wash made with pure watercolor. Inks contain less pigment and are less absorbent. The opaqueness of gouache paint, which is very heavily pigmented, can provide effective tonal contrast to the luminosity of watercolor. Tempera paints, which are water-soluble, have great permanency and can also be successfully combined with watercolor. In the paintings of the late John Piper, one can see how effectively watercolor, gouache, pen and ink, colored inks, pastel and wax resist can be combined. If exactly the kind of texture you want to produce can best be achieved by harnessing materials together in an unorthodox way, then you shouldn't worry too much about purist attitudes to watercolor. On the other hand, there is no great virtue in mixing media in the hope that it might help resolve problems that have more to do with fundamental weaknesses in the work as a whole. A "self-sharpening" wax china marker

pencil produces a soft, grainy line.

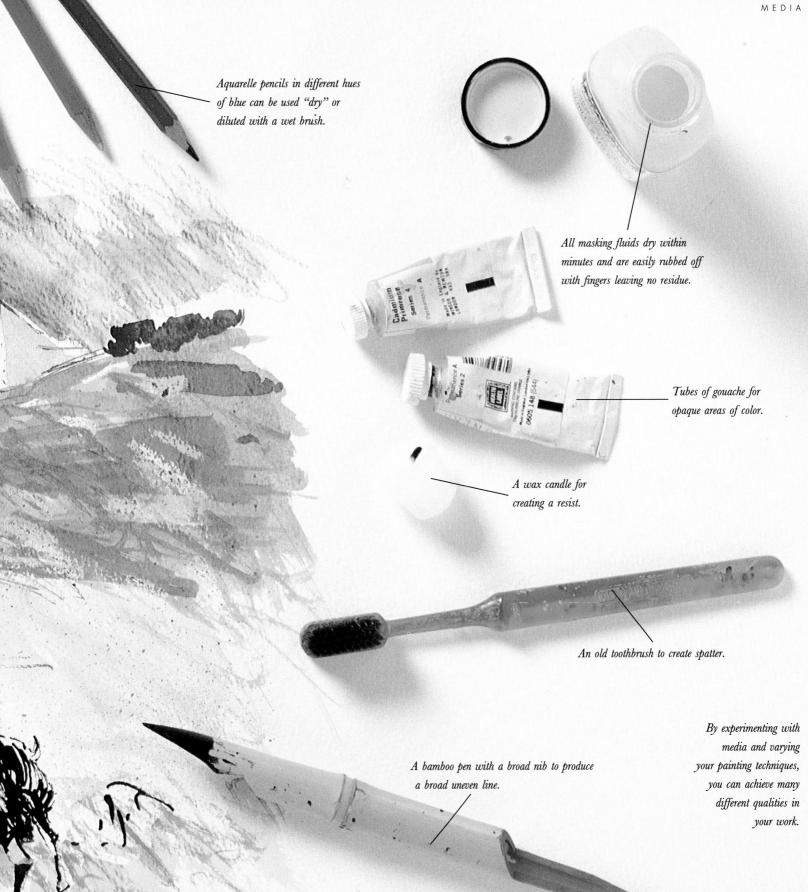

Paint Additives

GUM ARABIC/WATERCOLOR MEDIUM

This is a mixture of gum arabic and acetic acid, which acts as a binder and extender. It is particularly useful when working on top of several layered washes to prevent the color from sinking. Watercolor glazes are enhanced by the addition of gum arabic.

ABOVE Diluted gum arabic. It can be mixed in varying proportions with watercolor pigment.

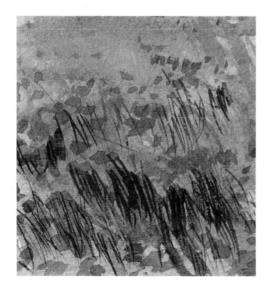

RIGHT An example of a brighter color mixed with gum and laid over layered washes — notice how the color retains its tonal strength.

OXGALL LIQUID

This additive is generally available in different-sized containers. It is generally used to improve the wetting and flow of watercolor paint. To improve the acceptance of watercolor on various

papers, the liquid oxgall is diluted with water and used as a primer. It can also be mixed directly with the paint to produce a smoother flow of color. Additionally, it can be used as a flat wash (with a touch of color) over a finished painting to bring colors together tonally.

PREPARED SIZE

You may find a particularly attractive paper to work on which is too absorbent for watercolor. Prepared size is used to make the paper less absorbent. It should be warmed gently before use so that it is free flowing and can be brushed directly onto the paper and left to dry. Prepared size can also be useful as a base for wetin-wet painting to prevent the color from spreading too much.

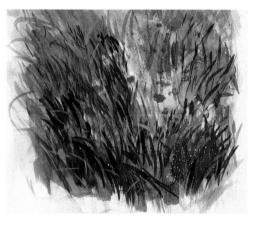

LEFT Colors applied wet-in-wet onto paper that has been sized by hand.

VARNISH

If a watercolor is to be framed under glass, it is not really necessary to varnish the surface. There are, however, a number of paper varnishes made from synthetic resin dissolved in turpentine, which the manufacturers claim do not affect the color or tone of the painting.

RICE STARCH

Nineteenth-century watercolorists sometimes added fine powdered rice starch to the color mix to produce a dry, pastellike quality. In an age of aerosol sprays, rice starch is becoming increasingly difficult to find.

Pens and Pencils

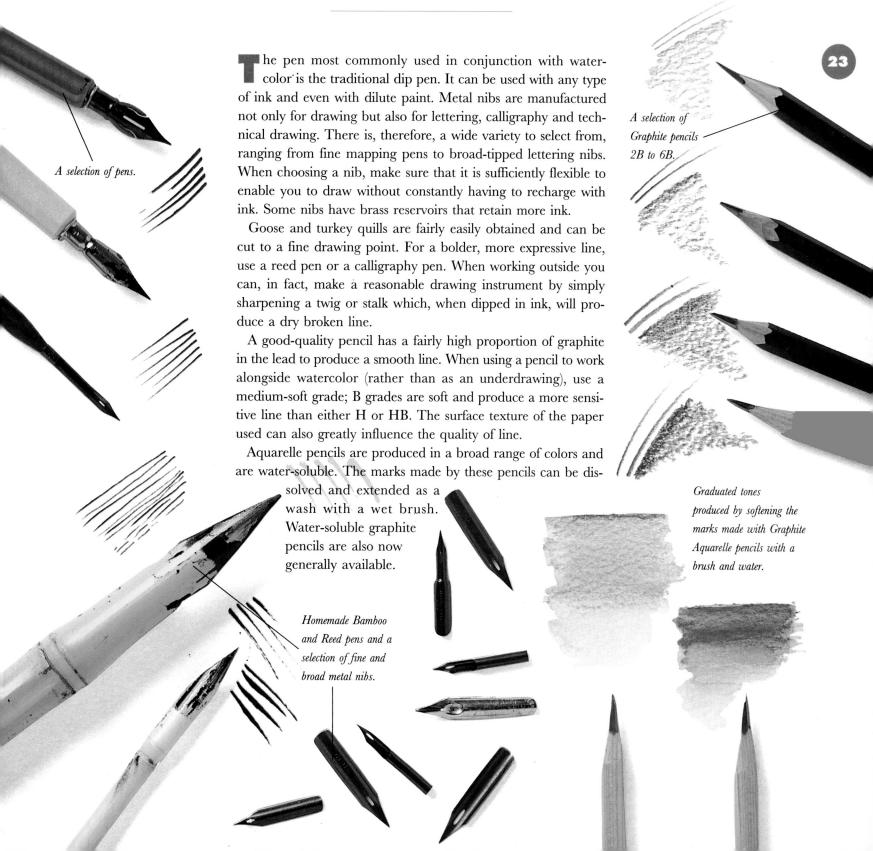

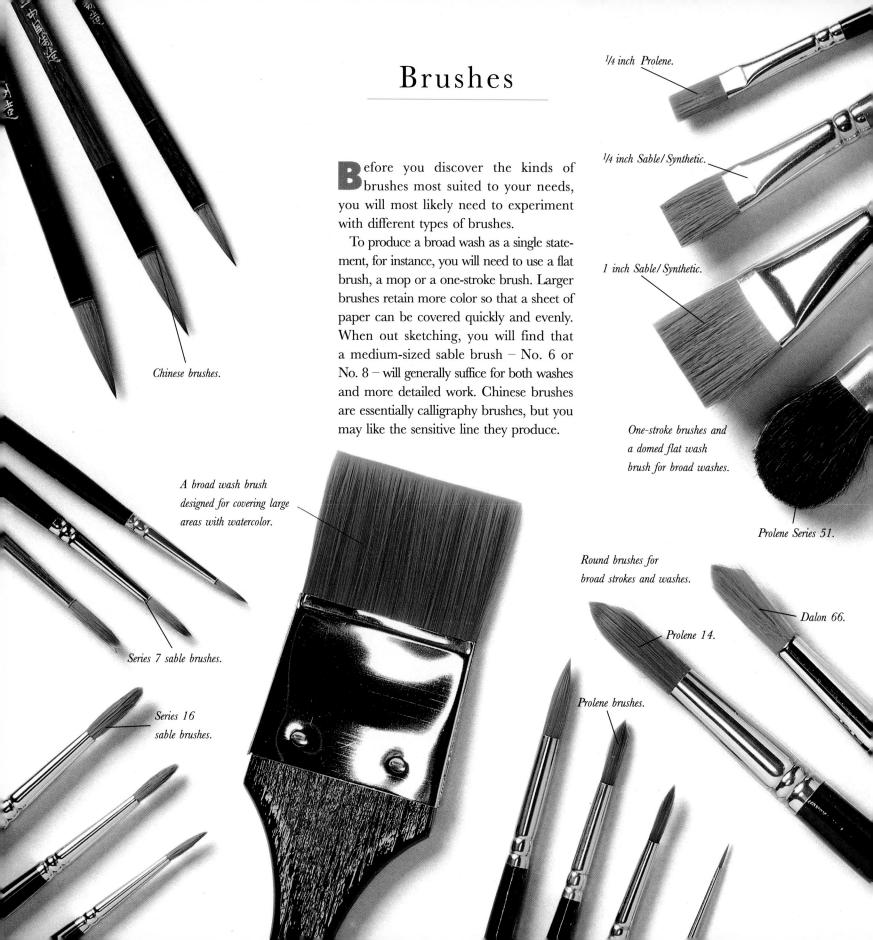

Holding Brushes

Just as a person's signature is highly personal, a painter will handle everything in terms of his or her own brushwork. You will sometimes hear artists and art critics talking about the "handling" of a painting. That has to do with the individuality of the artist's touch. We recognize the difference between, say, a watercolor by Richard Parks Bonington and one by James Abbot McNeill Whistler by the difference in handling. The brush is an extension of the artist's eye – revealing the most tentative trace of the artist's feelings.

In order to gain graphic control of the

In order to gain graphic control of the hand, the painter William Coldstream worked as an assistant sign-writer. The painting of letterforms is an excellent way of learning brush control.

For detailed work, the sable brush is usually cradled between the first and second fingers with pressure applied by the thumb. In my experience, the broader the brush, the farther down the handle it is held. Try holding the brush at the very tip of the handle, so that the smallest movement is amplified. Practice making strokes upward and downward, slowly and very rapidly, until you feel you have brush control.

A Chinese brush is held at the top of the handle for a more fluid movement.

Practicing line control with a No. 4 sable brush.

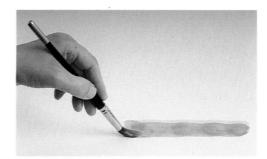

A round brush is held loosely to produce a broad wash.

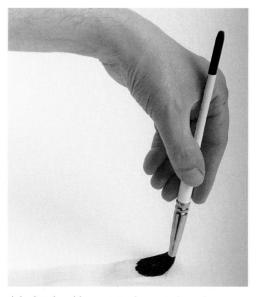

A backstroke with a mop produces a pale wash.

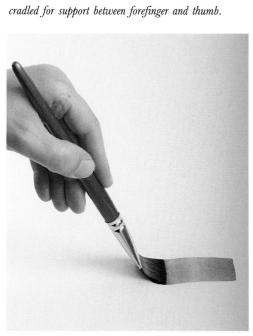

Controlling a fine sable brush. Notice how the brush is

A broad one-stroke brush is used to lay a wash.

It is held farther down the handle to ensure greater control.

Maintaining Equipment

26

BRUSHES

Sable brushes are expensive, and it should be an unbroken rule to clean them each time after use. The life of a sable brush will depend on the way it is used as well as how thoroughly it is cleaned. Try to keep brushes for different functions; a sable brush can take quite a lot of punishment, but try not to use it for any kind of scrubbing action. That will loosen hairs in the ferrule and spoil the shape of the brush.

TO CLEAN A BRUSH

① Pour a little detergent into the palm of your hand. Gently rotate the bristles to soak up the detergent.

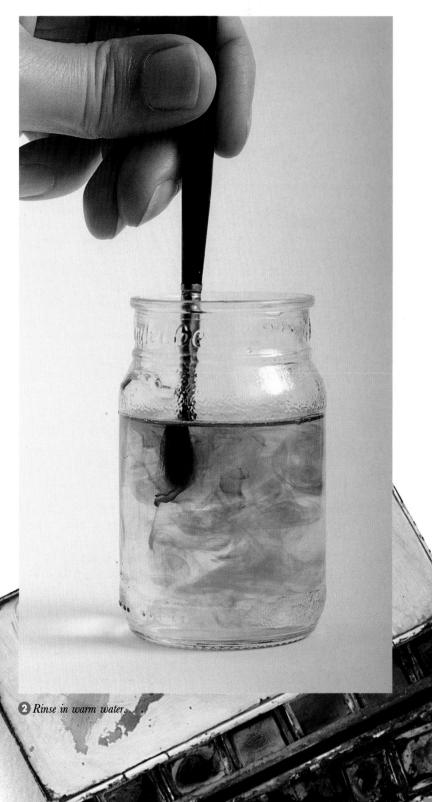

3 Reshape the bristles with your finger and thumb. Store brushes when not in use in a cylinder or on a protective backing cardboard (as illustrated right).

PAINTBOX AND PALETTE

Clean all mixing palettes after use and, more important, allow pans of watercolor to dry out before closing the box. That might prove difficult when you are traveling; if so, open the box when you return to your studio so that the colors can dry.

When using tubes of color try to get into the habit of screwing the cap back on the tube *immediately* after use.

OTHER MATERIALS

A roll of paper towel always comes in useful whether you are working inside or out.

Keep two jars for mixing and rinsing color and make sure they have screwtops that are watertight.

PROTECTING YOUR BRUSHES

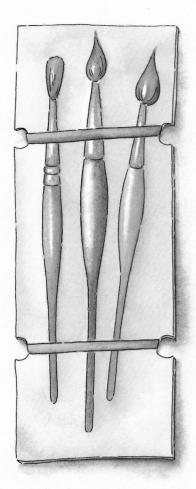

Good-quality paintbrushes are expensive to buy, but will give long service if looked after properly. One of the most common causes of damage is the inadequate protection of the brush hairs during transit. Avoid this by either retaining the plastic cap that comes with the brush, or buy a specially designed rigid tube. A very simple and inexpensive alternative is to make your own. Cut a stout piece of cardboard taller than your largest brush. Cut four semicircular indents in the sides, as shown in the illustration above. Place two thick elastic bands around the cardboard in the indents.

Then slide your brushes through the elastic bands.

Washes

ne of the main prerequisites for becoming a good watercolor painter is the ability to lay a good wash. By that, I mean being able to cover a relatively large sheet of paper with an evenly laid tone of diluted color.

For the beginner, this is often the most daunting aspect of watercolor painting. There is no need for anxiety, however, provided that you take account of the following factors. First, the quality and surface texture of the paper are important – whether it has too much size content or too little, whether it is too smooth or too coarse. Second, the angle of your sketchbook or drawing board and the angle of the brush to the paper can assist the flow of color. Third, the amount of color loaded in your brush and the size of the brush in relation to the area to be covered makes a difference. Finally, the deftness and speed at which you work and (if you are working outside) the heat of the day, the wind or a damp atmosphere affect the evaporation of color. You can apply washes freely as Turner did, without precise boundaries, or you can develop a blocking-in technique as John Sell Cotman did, by dividing the subject into simple shapes or blocks of color. Freshness of color is one of the main characteristics of watercolor, and this is lost to some extent if too many washes are superimposed on one another.

MIXING A WASH

Being a painter is sometimes like being a good cook – the mixing of the ingredients can greatly influence the finished result.

Though I would not personally worry about the kind of water used for producing a wash, there are some painters who believe that distilled water or even rain water will produce a better wash than hard water from a faucet. There is some truth in this, since hard water has a tendency to curdle the paint.

Unless you find it too cumbersome, you should always have two jars of water – one for mixing color, the other for rinsing your brushes. That will ensure cleaner results and you will need a change of water less often.

It is always better to mix more of a tint than you will actually need; the time taken to mix a fresh tint can spoil your concentration, and it will be difficult to match the first mixture exactly.

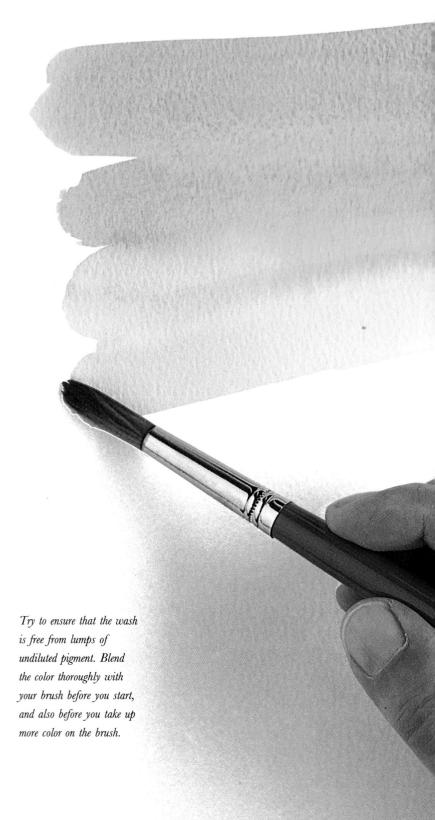

STRETCHING PAPER

You will need a drawing board, or a similar firm support that is larger than the size of the watercolor paper. The paper is fastened to the board with gummed tape (gum-strip). This is coated on one side with a water-soluble glue that becomes tacky when moistened with a sponge.

First, immerse the paper completely in a tray filled with a few inches of cold water – a photographer's developing tray is ideal.

- ① Allow the paper to soak so that there are no dry patches, then lift it out of the tray and drain off any excess water.
- 2 Next, place the paper centrally on your board and, with a finger, squeegee the edges so that they are just damp.
- Cut the gum-strip into four pieces
 longer than the four sides of the paper itself. Wet the tape with a damp sponge.
- ② Press the tape firmly into position along each edge of the paper so that it covers an equal width of board and paper.

The paper should then be allowed to dry out – you can assist the drying after 15-20 minutes with a hairdryer.

Watercolor papers of 300 gsm / 140 lb and heavier papers do not require stretching.

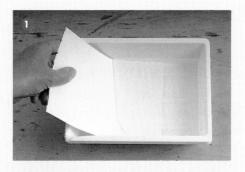

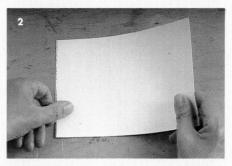

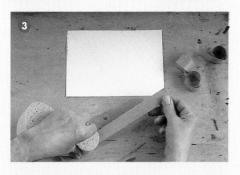

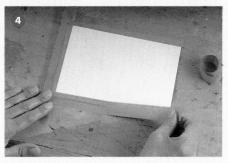

A flat wash made with a 1½ inch flat brush and Fabriano (ROUGH) paper.

LAYING A FLAT WASH

If you are laying a flat wash on dry paper, mix a sufficient quantity of paint in your mixing tray and fully load the brush. Tilt your board or sketchbook toward you at a slight angle. Make your first stroke across the top of the paper. As the color begins to collect at the bottom of the stroke, pick it up with your brush and continue in this way with successive strokes, allowing a slight overlap where they join. Work toward the bottom of your sheet of paper, or the area you wish to cover, and remove excess paint by squeezing out your brush and lifting the residue so that the wash is even in tone.

An alternative method is to dampen the surface of the paper first – this is particularly desirable on papers that are heavily sized. Having dampened the paper, make sure that the surface is mat and not too wet. Any excess water should be blotted off before laying the wash. Tilt the board and proceed as before. A flat wash laid onto damp paper is softer and more diffused than a wash on dry paper.

WASHING OUT

This is a way of reversing out white shapes from previously laid washes of color. When the wash is dry, take a fine sable brush dipped in clean water, and soften the color where you wish to remove it. Blot off the color carefully with tissue.

You may need to repeat this operation until the paper appears as a clean white shape.

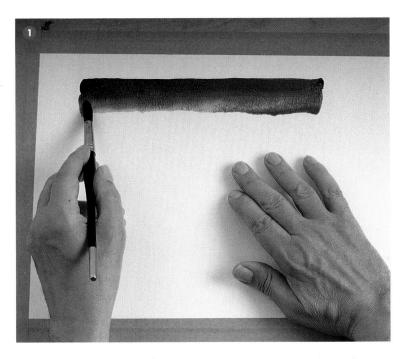

GRADUATED WASHES

A graduated wash starts with the color at full strength and then, by dilution, the tone becomes paler until it is just a trace darker than the paper itself. Again, as with a flat wash, you can work either on dry or damp paper.

- Mix the full tint and with a broad brush make the first stroke horizontally across the top of the paper.
- 2 Then, pick up a little water on the brush and dilute each stroke.
- 3 Continue until you have achieved a satisfactory gradation of tone.

before you buy expensive papers.Change damping water often.

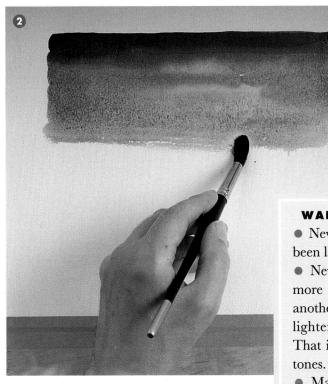

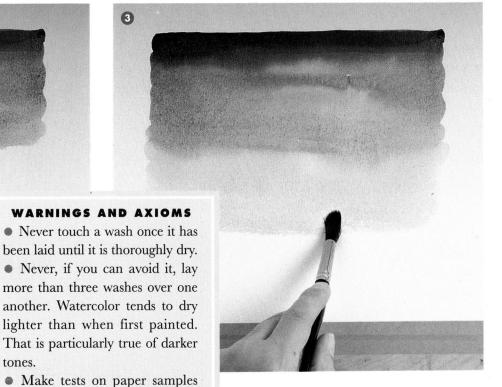

Wet-in-Wet

elacroix said that, "One always has to spoil a picture a little bit in order to finish it." Wet-in-wet is one of those techniques that is unpredictable and difficult to control. If you are the kind of artist who enjoys risk-taking, however, then the uncertain outcome of allowing washes to merge into one another while wet will appeal to you.

When working wet-in-wet you can dampen the paper first, by sponging either the whole sheet or local areas of the painting such as the background or the sky. While the paper is still damp, float one or more washes onto the surface. The pigment will immediately be absorbed as it spreads, coagulating and forming rivulets of varying intensity. You can assist the flow by tilting your drawing board upright so that the colors run down, blending randomly with one another. A degree of control can be exercised by systematically blotting off patches of color with tissue or cotton batting. More color can be added before the first washes have dried out completely.

All techniques serve one purpose – to enable you to convey the particular qualities of some phenomenon you have witnessed yourself. There is no particular virtue in using the wet-in-wet technique for its own sake. The application of this technique is best suited to strongly atmospheric images – a landscape emerging from early morning mist, a turbulent sky or a seascape are all examples that come to mind.

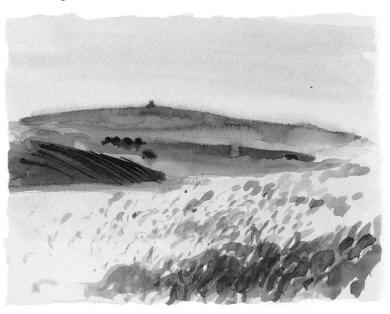

RIGHT An exercise
using a large brush to
make loosely painted
slabs of color on a
dampened sheet of paper.

BELOW A rapidly executed sketch painted directly from the subject. Washes have been applied wet-in-wet onto RIVES HP paper.

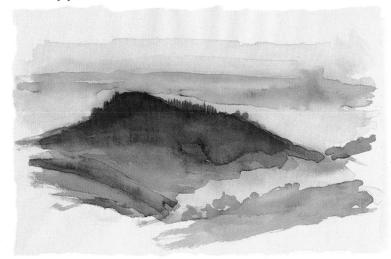

LEFT AND RIGHT Two studies of a hillside in Tuscany painted directly from observation early in the morning when the mist rises from the valley.

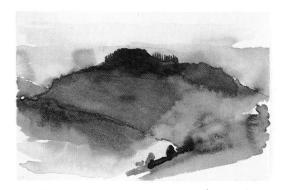

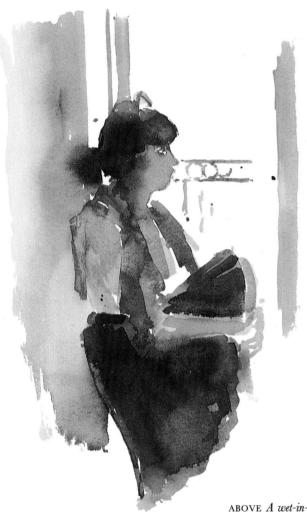

ABOVE A wet-in-wet portrait painted against the light (contre jour) in 10-15 minutes.

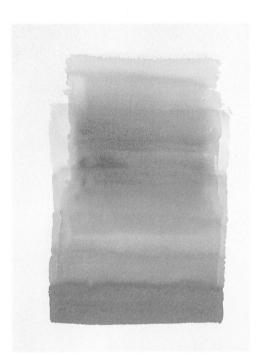

LEFT A wet-in-wet exercise using warm washes to produce subtle mutations as layers of color merge.

BELOW This watercolor of a Swiss landscape demonstrates how the wet-in-wet technique can be controlled to suggest space and atmosphere.

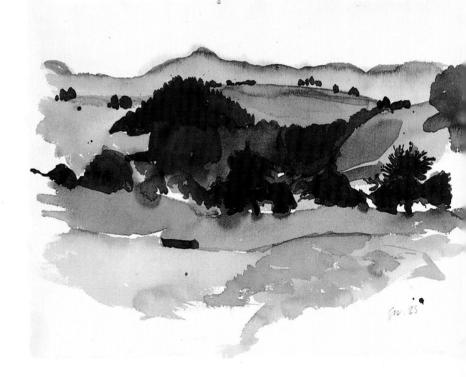

34

The dry brush technique is essentially a means of providing texture in watercolor painting. It is also a way of lending graphic expression to what might be an otherwise static painting. When painting a landscape scene, for instance, you may feel the need to suggest rhythm and movement – particularly with the rendering of crops, grassland, trees and foliage.

In order to gain confidence in using this technique, you should make a few mark-making trials on scrap paper. You will need a textured paper — rough or CP (cold-pressed). The brush should be starved of water before lifting pigment from your palette. Hold the brush lightly and make rapid strokes across the paper in a kind of sweeping action. The combination of dry pigment and the textured surface of the paper will produce a broken, granular stroke, which makes a pleasing contrast to flat washes.

Try different colors and vary the amount of water used. You could also experiment with different kinds of brushes.

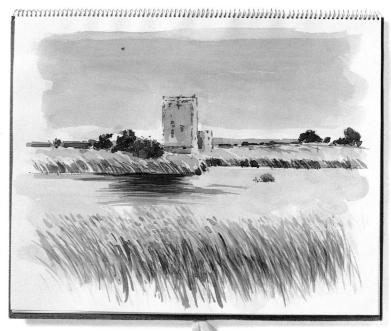

ABOVE Threave Castle, Scotland. Dry brush strokes have been used mainly in the foreground for reeds and grasses.

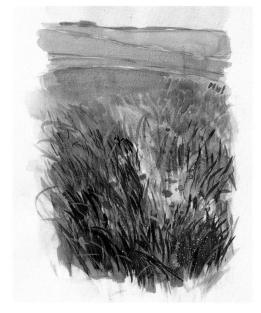

ABOVE Poppy field.

Strong directional strokes of dry color evoke the wavelike quality of crops and grassland.

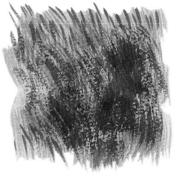

Thin broad washes are used for the distant — poppy fiell.

Dry brush work is used on the figure.

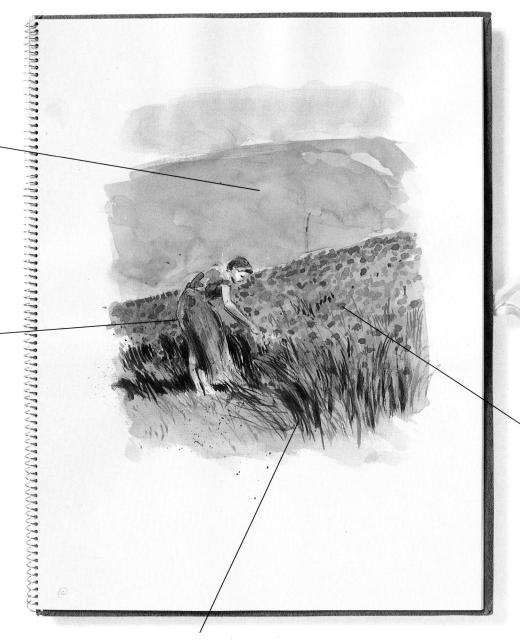

Gum arabic is added to red to stop the color from "sinking."

Dry brush strokes used for the field add a strong rhythmic element to the painting.

Resist and Spatter

These techniques are useful mainly to extend the atmospheric and textural qualities of watercolor. In landscape painting particularly, we sometimes need to find ways of responding visually to the rich complexity of natural forms and the effects that climate can have on them.

Masking fluid and candle wax are both substances that are resistant to water. They are usually applied to the surface of the paper before any washes are laid. Masking fluid is a kind of liquid rubber that dries rapidly. It has a distinctive pale lemon color, so it is very easy to see the marks you are making. It can be applied with a brush (preferably an old one since the fluid is difficult to clean off) or a dip pen with a broad nib.

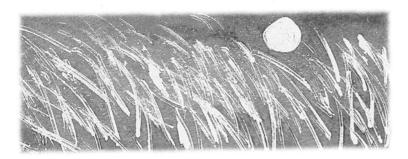

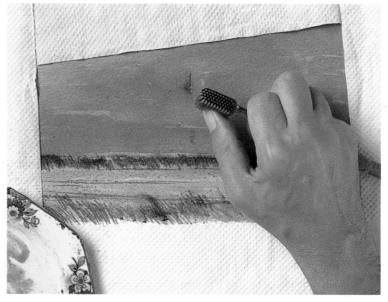

LEFT TOP This speckled texture is produced by using a wax candle as a resist.

LEFT MIDDLE Masking fluid has been used in

rapid strokes to create this grasslike texture. LEFT BOTTOM Tone created by spattering.

ABOVE The bristles of an old toothbrush are loaded with color and spattered onto a maskedout area of the painting.

In addition, it can be spattered with a hog's-hair brush. When you have completed your masking out, and the fluid has dried, apply a wash of color over the area you wish to cover, and allow to dry. When thoroughly dry, peel off the masking fluid, which will now look like a rubbery skin, by burnishing gently with an index finger, taking care not to damage the surface of the paper. The drawing you have made will then appear as a white shape reversed out of the watercolor wash.

Candle wax is more difficult to see, therefore the results tend to be more random. You can use the wax as a flat wedged shape, or it can be sharpened to a point.

Spatter enhances the granular quality of the painting. You can either use a toothbrush or a hog's-hair brush. Load paint on plentifully and drag the bristles against the blunt edge of a knife or wire mesh. Areas of the painting can be masked off with scraps of paper where you don't want spatter to appear.

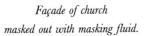

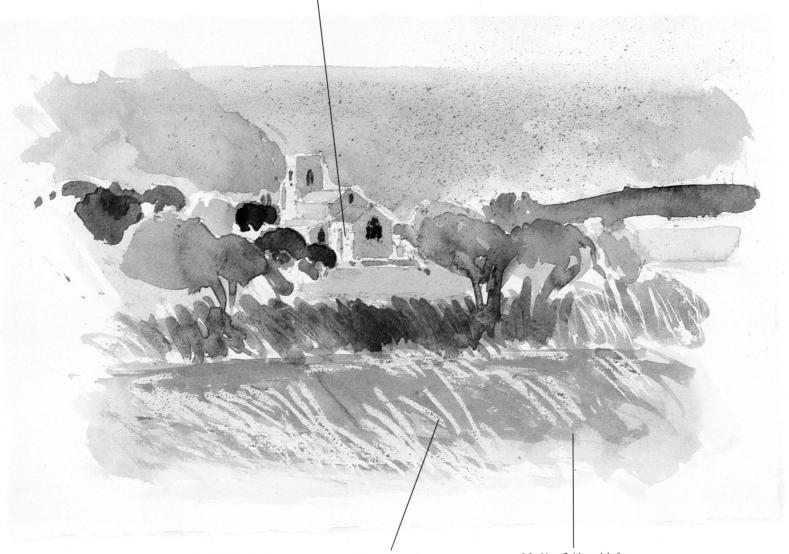

A country church in England.
This watercolor was painted on site in the late summer when colors and tones become more muted. The wax resist was used after a preliminary drawing had been made in pencil.

Wax resist used on hedges and field.

Masking fluid used before applying a wash of Burnt Umber.

Brush Drawing

hen you are painting from direct observation you will generally be too absorbed in your subject to think very much about the kind of brush you are using or the kind of marks that it makes. In order to extend your range of mark-making, you should try a number of exercises that allow you to concentrate on the quality of image produced by using different types of brushes. Try, for instance, making broad strokes of color with a Hake 3 inch and, when dry, overlay a series of loose calligraphic squiggles with a No. 6 sable. Also try using brushes that are not normally associated with watercolor - such as a hog's-hair brush with a flat or round tip. That will produce very brittle strokes of color. Chinese brushes, too, make a characteristic mark that is very different to that made with a sable. By extending your markmaking vocabulary in this way, you will feel more confident in dealing with most subjects. You will also be able to produce watercolors that are richer in terms of texture and contrast.

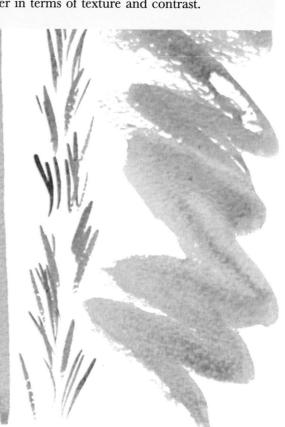

Exercises using different types of brushes. Notice the effect of overlaying fine brushstrokes onto those made with broader bristles. The main purpose of carrying out this kind of exercise is that you will gain confidence in making lucid brushstrokes without feeling in anyway intimidated by the medium.

Brushstrokes made with Sable, Ox-hair, Hog's-hair and Chinese brushes.

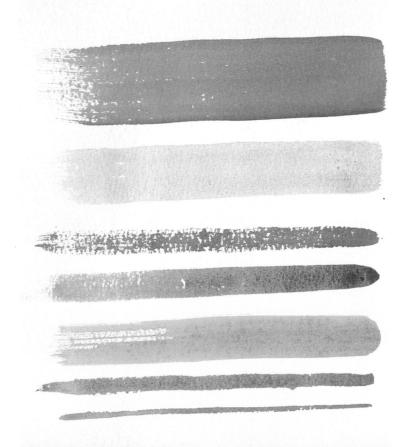

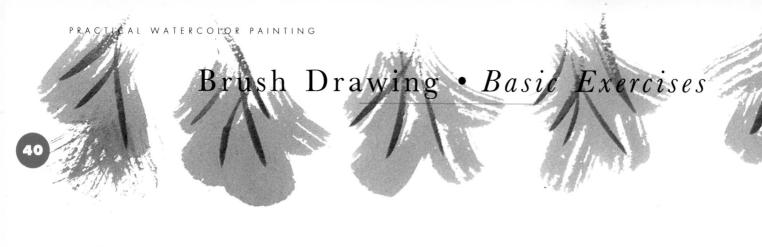

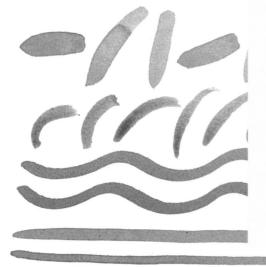

his is the purest form of watercolor painting. To draw directly with a brush can be an immensely satisfying form of graphic expression. Drawings made with a brush and watercolor are often less self-conscious than those made with pen or pencil. That probably has something to do with the fact that the softness of the image lends a fluency to the drawing that is difficult to obtain in any other medium.

Almost any mark you make with a brush is a statement about form and shape as well as about color and tone. Most important, you should first discover what kind of marks can be made with different types of brushes. Try to work in terms of the medium, rather than trying to conceal the unique character of brushmarks by overworking the drawing.

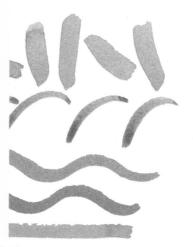

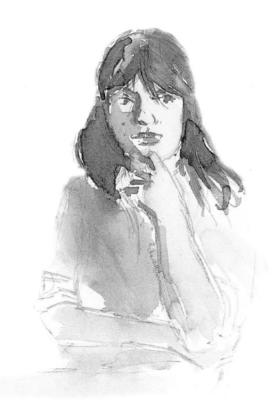

LEFT A portrait study made with a No. 5 sable brush. The underlying drawing has been made from direct observation using a pale wash of Alizarin Crimson and Lamp Black. When dry, other washes have been rapidly overlaid wet-in-wet.

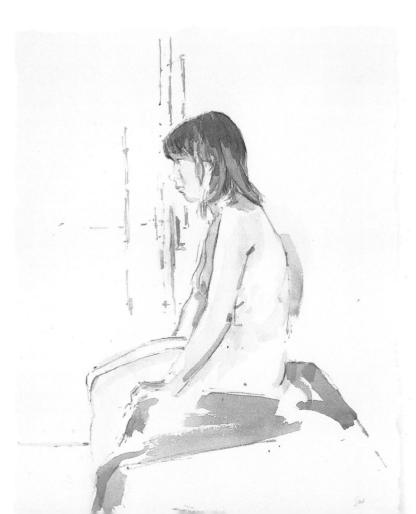

Pencil and Wash

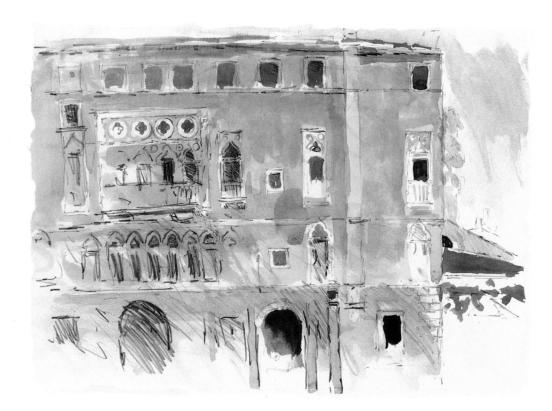

LEFT This page from a Venetian sketchbook shows the right kind of balance between pencil and color.

RIGHT Another sketchbook page on which drawn pencil marks and color work well together.

he earliest watercolors were really tinted drawings — washes of pale color were laid over pencil studies as a kind of embellishment to heighten the drawing.

Quite often the tinted drawings were preliminary studies for engravings. A number of early English watercolorists, Turner and Cotman included, were employed to add watercolor to readymade prints.

Line and wash – the classic watercolor technique – came into its own when wealthy 18th-century patrons commissioned picturesque studies of scenery along the "Grand Tour" of Europe.

John Cozens (1752-97) was one of the first watercolorists to use line and wash to depict the Italian landscape. By the beginning of the 19th century, watercolor painting was considered to be an art in its own right. Turner, much influenced by Cozens, traveled to the Continent in 1802 as far as the Swiss Alps. There followed a series of watercolor paintings recording a journey down the Rhine, and in 1819, at the age of forty-four, Turner visited

Italy for the first time and produced some of his finest water-colors. The tradition of classic watercolor established by the early English watercolorists has continued to the present day – along-side computer-aided photography and video-recorders! My own view is that you cannot truly know a place until you have drawn it. When I sit before a scene trying to register line for line, tone for tone, I gain an understanding of the subject that is indelibly stored in my memory.

For pencil and wash I prefer to use a paper made from 100% cotton – Saunders or Fabriano are ideal. The soft surface of these papers is very receptive to both pencil and watercolor. A paper that is too heavily textured tends to break up the pencil marks; too smooth a paper produces unsatisfactory washes.

The balance between line and wash is critical – there is no point in simply filling in a previously drawn pencil outline with washes. The pencil drawing might provide an underlying structure, but it is also an integral part of the whole painting.

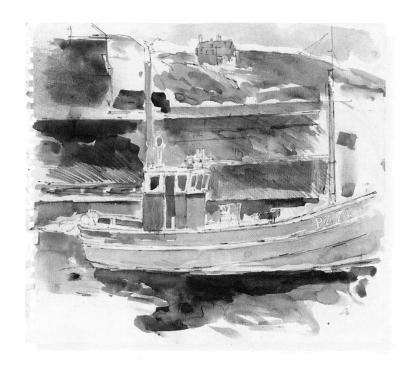

I find a medium-soft pencil, such as 2B or 3B, ideal to produce the right tonal balance between line and wash.

Perhaps the most difficult aspect of this technique for the beginner is to learn how to be selective. When you start to draw, you need to be conscious of the fact that the drawing is only a part of the total image — you must allow for the fact that subsequent washes of color will work alongside the pencil drawing, rather than displace or color it. In other words, both line and wash should be used descriptively to produce a single image without any separation of technique.

ABOVE The city of Segovia drawn from a distance in pale pencil tones with delicate washes that do not cancel out the drawing.

RIGHT A tentative
use of the pencil in
this painting allows
colored washes to
work independently.

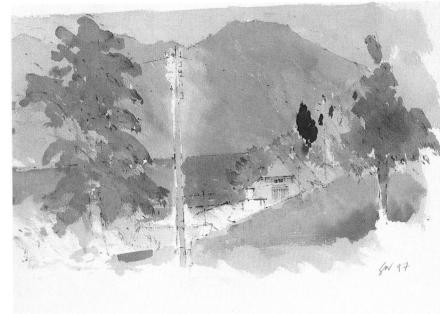

en and ink when used with washes of watercolor can work particularly well in paintings that rely on closely related tones. The drawing pen produces strong linear marks that provide an interesting contrast to flat washes of color.

The 17th-century painter Claude Lorraine (1600-82) produced pen and wash drawings of great lucidity, using washes of Bistre, Sepia and Indigo. This strongly monochromatic form of line and wash painting also found favor with the English painter Samuel Palmer (1805-81). Palmer's visionary paintings of Shoreham are charged with symbolism.

The traditional dip pen can be useful when used with a variety of nibs – the finest of which are known as mapping pens. Broader drawing nibs are usually quite springy and are flexible enough to suit most subjects.

Reed and quill pens, which historically preceded the metal nib, produce a wonderful irregular line that is less mechanical than that produced by the conventional dip pen.

You can make your own pens with short sticks of bamboo of different diameters. With a sharp knife, trim off about 1½ inches at an acute angle until you have a sharp point. If you cut half a dozen pens, you can vary the tip of the pen from a fine point to a broad chisel shape. You will find that the spongy texture of the hollowed inside of the bamboo retains the ink sufficiently to be able to draw freely. Old fountain pens can sometimes produce an interesting quality of line, particularly if the nib is worn.

Felt- and plastic-tipped pens are convenient to use, although the uniformity of line that they produce can be restricting. If you

A landscape in Italy. Washes were applied after the pen drawing was completed. Care must be taken not to cancel out the sense of light created by the broken line of the pen drawing.

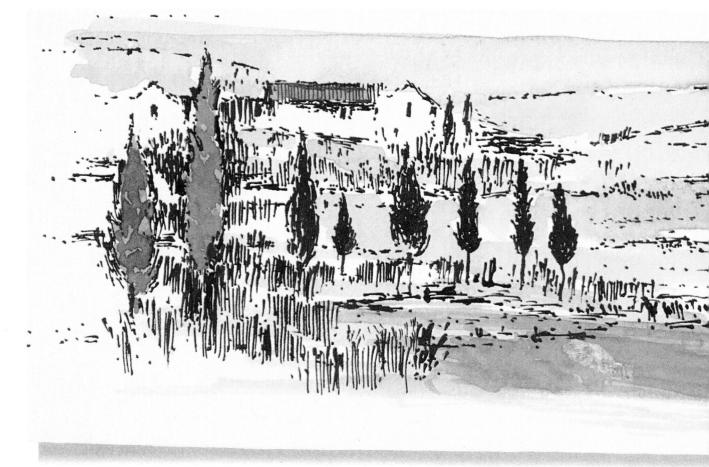

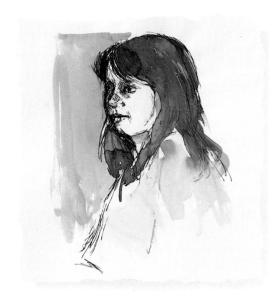

do not want your drawn lines to "bleed," you should use a waterproof ink. On the other hand, you may happen to like the way that non-waterproof ink will dissolve when watercolor is brushed over the surface. As well as black ink, there is a good range of colored inks, which are shellac-based and waterproof.

To gain experience of working with pen and wash, and to control tones, you could produce a Sepia pen drawing with overlaid washes graduating from Ocher to Burnt Umber on a toned paper. Try also a simple exercise in mark-making with different types of pens. It is important that you are able to work at ease with your materials — especially since mistakes in pen and ink are difficult to rectify. Finally, always try to work in terms of the medium — a good pen and wash drawing should bear the imprint of the materials used and not look like something else.

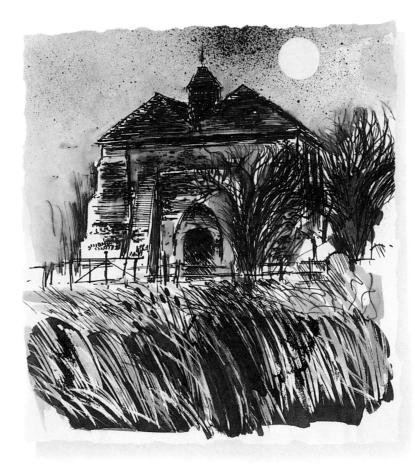

ABOVE LEFT
A portrait drawing made with a fountain pen using non-waterproof ink that has dissolved slightly after a wash of watercolor was overlaid.

LEFT A strong drawing made with a reed pen.
A single wash of
Cadmium Orange is used effectively.

The pale wash of

and grass.

Layering Techniques

hen two or three transparent washes are laid one over the other, there are unexpected changes of color and tone. That, in essence, is the main characteristic of the medium - that color and tone accrue gradually, rather than being put down at full strength as they are in oil painting, for example.

Traditionally, the watercolorist works from light to dark – in landscape this usually means starting with the palest tones in the sky then going on to the middle-tones of the middle-distance and the stronger tones of the foreground. If you look at a watercolor by Cézanne, however, you will discover that the forms are made up of tiny vibrant patches of layered color. Moreover, each color is made to work throughout the whole painting and is not confined to a specific area.

If, for instance, you are painting a landscape view, the pale tone you have used for the sky might also provide an undertone for hills, grass, shadows and so on. Similarly, other forms in the landscape, such as the foliage on trees, might need to be built up in closely related layers of color, rather than as a single wash.

Knowing precisely how color and tonal values can be established can only come from practice and experience.

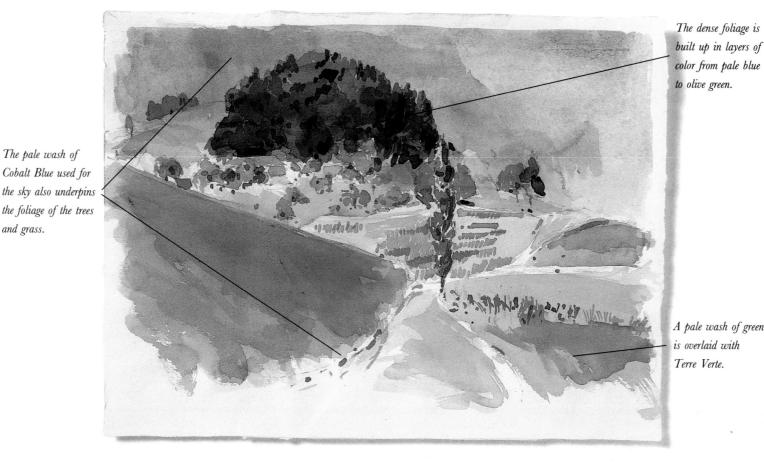

ABOVE A Tuscan landscape using layered color.

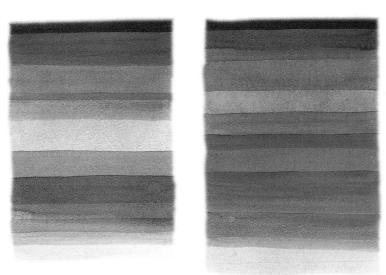

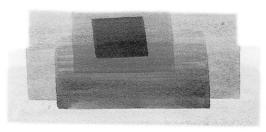

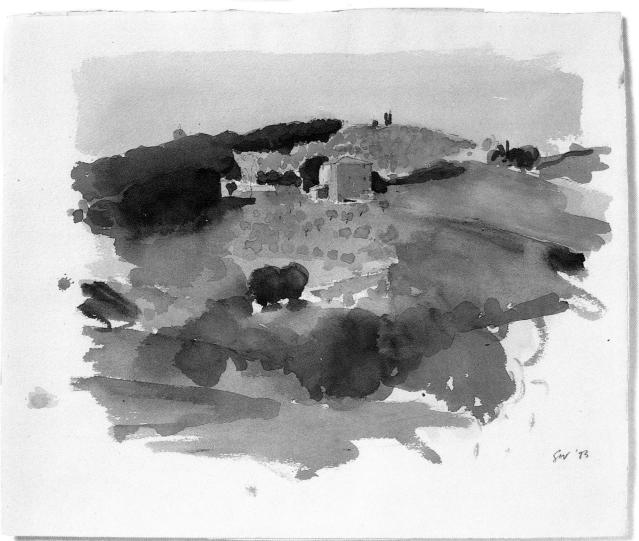

ABOVE An exercise in layering washes at different strengths – notice the tonal variation.

LEFT A Tuscan landscape which employs both layered color and wet-in-wet color. The silvery-gray of the olive trees is achieved by adding a little white body color. Tonal unity is maintained by restricting the number of colors used. ir Isaac Newton (1642-1727) was able to demonstrate that, although sunlight, or white light, is "uncolored," it is made up of seven colored rays: violet, indigo, blue, green, yellow, orange and red. We see color in objects that reflect and absorb these rays to a greater or lesser degree. An object that reflected the rays completely would be white or uncolored. If that same object absorbed the same rays, it would look black.

The artist working in watercolor must consider color in an entirely different way to the artist working in oils, acrylic or gouache. The full color value of a watercolor painting accrues as one transparent film of pigment is laid over another. This demands a certain amount of premeditation on the part of the artist inasmuch as he or she must be aware of the effect that one or more colors will have when combined to produce a particular hue. You need to be aware of the way that different color combinations can produce the colors required for the subject being painted. If, for instance, you were painting a Mediterranean landscape, the darker olive greens might be mixed from Lamp Black, Gamboge Yellow and Burnt Umber. The silvery color of the leaves of an olive tree, on the other hand, might be mixed from a combination of Viridian, Naples Yellow and a little white body color. You will obviously need to experiment with washes to discover for yourself exactly how to achieve the colors you are searching for.

Colors can basically be mixed in four ways. They may be fused together in equal quantities thus creating a new color. A slight

An irregular color wheel that heightens awareness of the transparent nature of the medium.

trace of one color can be used to diffuse or moderate a stronger color. A third color might serve to break the color resulting from an equal mixing of the first two. Opaque shades and tints are created by adding black or white with either pure or previously mixed color.

Remember that every color in your paintbox represents a tone as well as a color – if the color is applied with a brush starved of water it can appear as opaque as gouache or, conversely, when greatly diluted, as a pale tint that is only a fraction darker in tone than the paper itself.

We see color in nature as a harmony of contrasts – light against dark, one complementing another, cool against warm. At the same time every object has its own unique color. The specific or "local" color of a tiled roof might be a terra-cotta red but, like all colors, it is modified by light. The appearance of color is dependent on how and where it is placed – the English painter Walter Sickert (1860-1942) used to say that, "the color in the shadows must be the sister of the color in the light." Everything is relative; the brilliance and intensity of a fishing trawler painted red would be considerably enhanced by the drab color of the surrounding harbor walls.

The artist can only hope to produce an approximation of the colors he or she sees in nature – the best watercolorists work in terms of suggestion rather than overstatement. The watercolors of Cozens, Cotman, Turner and Cézanne look effortless – as if they have captured a moment in time, rather than being the product of prolonged study. There is a certain "hit or miss" element in watercolor painting, which sometimes means that for every painting you produce that is reasonably satisfactory, there will perhaps be three or four that have to be abandoned. Unlike oil painting or acrylic, watercolors rarely benefit from being reworked.

The best way of improving your understanding of color is to work as often as possible from direct observation – matching the colors you see to the pigments in your paintbox. In cultivating this habit, you will begin to remember how certain colors and tones are achieved and, in time, you will be able to look at colors in the landscape and know in your own mind exactly how you would mix such colors.

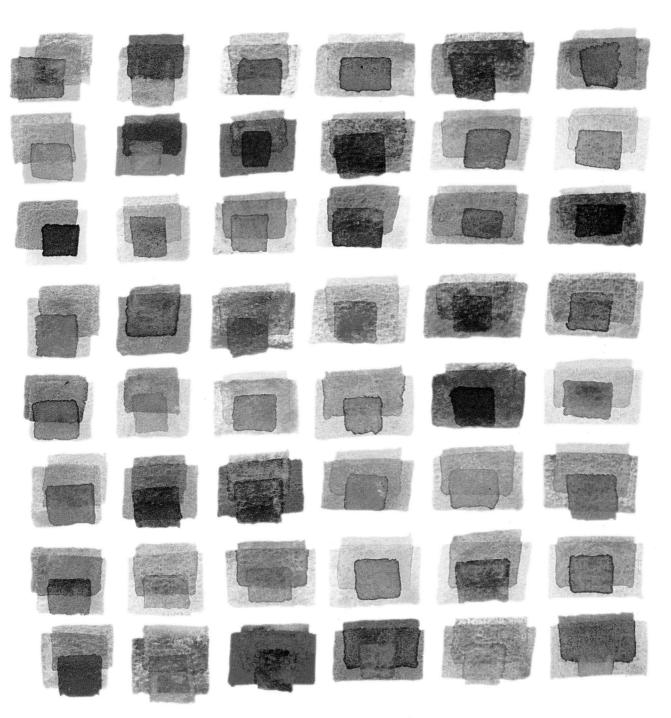

A useful exercise in creating color by overlaying two or three patches of different colors in varying tones. Notice particularly the effect of laying pale, dilute washes over more solid colors.

Tone

50

RIGHT A landscape in Tuscany. A wash of Venetian Red is applied freely using a large brush on Saunders HP paper.

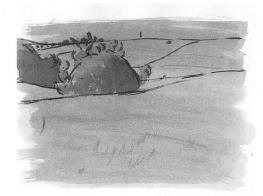

LEFT The main forms of the landscape are painted in with Umber using a No. 6 sable brush.

RIGHT Greater tonal definition is given to the painting by adding darker washes and a little body color in the foreground.

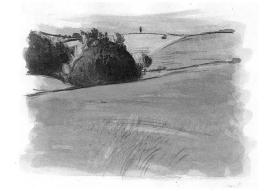

RIGHT Graduations of color painted as a tonal scale – this simple exercise can help to increase

your understanding of the enormous tonal variations that can be produced with watercolor.

The way that areas of light and dark are distributed in your painting is as important to the overall design as the placing of objects in your composition. One of the main reasons why the watercolors produced by beginners sometimes fail is that they lack tonal unity.

It is surprising how often poor color values in a painting are due to not giving sufficient consideration to tonal relationships. In order to understand how tones can work in your painting, you should first try to forget the convention of describing forms by defining them with a drawn outline. Get into the habit of seeing things in terms of degrees of tone – light, medium and dark.

You could try, for instance, to produce a watercolor painting in which you forget all about local color and restrict yourself to using three related tones. Additionally, you could work on a tinted paper — buff-colored for warm tones, gray for cool tones. Watercolor tones depend on the amount of pigment you use. Light tones are produced by adding a trace of pigment to a lot of water, dark tones with just enough water on your brush to soften the pigment. The sense of depth and recession in landscape, is recreated in painting by the intervals between light and dark tones—the tones farther away from the eye are lighter than those in the middle-distance, and become progressively darker toward the foreground.

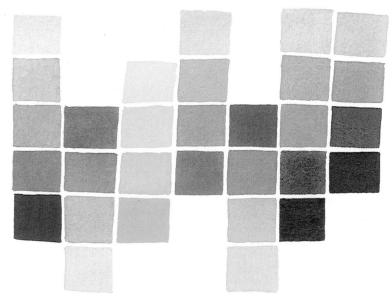

Individual hues all have their own tones. The three brightest primary colors, for example, would register as follows on a 0-10 scale: yellow 4, red 6 and blue 7.

When you are painting a landscape view, look at the scene before you through half-closed eyes. This results in a kind of diffused blurring of detail, which enables you to judge tonal values in a more unified way.

In the best tonal paintings, detail is sacrificed in order to give more emphasis to the design of the painting. In landscape, tonal harmonies are usually found at first light and toward dusk, when conspicuous detail is lost in shadow and forms are softly revealed.

A basic tonal exercise that demonstrates how closely related colors and tones can be used to suggest depth and recession.

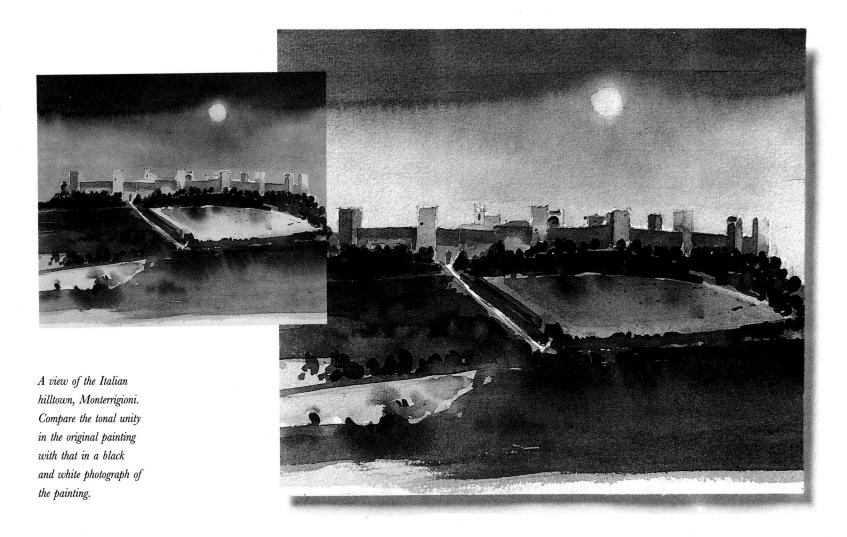

An arrangement of the parts of a work of art so as to form a unified, harmonious whole.

99

his simple definition from Webster's dictionary is as good as any – composition has to do with the conscious ordering of the various elements of a painting into a harmonious whole. Delacroix (1798-1863) said that, "one line alone has no meaning; a second one is needed to give it expression."

The process of composing begins from the moment you select a particular viewpoint, before you have made any marks on the paper. Objects in nature are never isolated – they are relative. Though a single feature might command your attention – a solitary church on a hillside, for instance – it is seen in relation to the broader view of surrounding hills and sky, roads and trees. If it was your intention to convey this sense of isolation in your watercolor painting, then scale would be critical, and you would paint the church from a greater distance. If, on the other hand, you were more interested in saying something about the architectural detail of the same church, then you would have to move much closer to your subject. Composition, in this sense, is determined by your intentions.

Landscape is without a doubt the most popular subject for watercolorists, yet it is potentially the most difficult to handle in terms of composition. Landscape is indeterminate and orderless – you need to have a strong sense of design to be able to visually harness all the random elements which are positioned at different levels and recede into the distance. One advantage that you have over the photographer is that you can simply leave out any detail you feel might spoil the balance of your composition. The composition of seascapes is very much dependent on where the line of horizon is placed. Supposing, for example, you wanted to make a dramatic stormy sky the main feature of your painting, then you would place the horizon line low in your composition in order to provide the right emphasis. Conversely, if you were painting a "Turneresque" sea study, then the

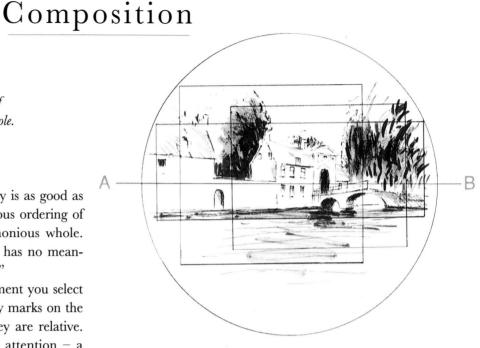

This diagram represents the circle of vision.

The different rectangles suggest the choices available in terms of composition.

horizon line would either be high in your composition or would disappear altogether.

Classical painters, such as Nicolas Poussin (1594-1665), often used pictorial devices to lead the eye toward the most important part of their composition. Paths, lines of trees, rivers and bridges were carefully positioned to draw the eye toward the group of figures that were the focal point of the composition.

The "acid test" of a well-composed painting, however, is that the viewer should be unaware that the artist has imposed any kind of predetermined plan on his or her work. A painting in which the composition is too self-conscious will distract attention from the subject itself. The artist needs to be something of a tightrope walker and a dancer – the basic framework of the composition supporting the free expression of the brushwork.

When painting a still-life subject you will find that you have much greater control over the composition since the objects you are painting can be arranged at will. We know that Cézanne used to spend hours arranging his still-life groups – changing folds in cloth, moving bottles, jugs and bowls of fruit until he felt instinctively the relationship to be right. This sense of "rightness" in

52

composition is not something that can be taught; it comes with observation and experience.

There are, however, certain established ground rules in composition that you might find helpful. The best known device for dividing space aesthetically is known as the "Golden Section." To give you some idea how this works, try the following simple experiment. Take a sheet of writing paper and fold it in half three times in succession. When you open the paper flat again you will notice that it is divided into eight equal parts. Draw a line with a pen on the fifth fold – this is the Golden Section on a 3:5 ratio

(alternative ratios might be 2:3, 5:8 or 8:13). This device works best in those compositions where there is a significant vertical element – a figure or even a tree or lamppost – that provides a kind of axis for the whole painting.

The process of composing a painting can continue even after it is finished. Try, for instance, placing a square window mount over a landscape-shaped painting in your sketchbook. You will discover that as you move the mount slightly you can isolate parts of your painting in such a way that it looks entirely different — and perhaps even better!

A simple viewing device cut from black cardboard will help you initially to isolate the main areas of interest in your composition.

erspective is really a kind of visual trick – it is the means by which we create the illusion of three dimensions.

We see things in depth – that is to say, we see objects disposed at varying distances from each other and from ourselves. When we draw "in perspective," we are trying to represent what we have seen in three dimensions on a flat sheet of two-dimensional paper. It is perfectly possible to do this by simply trying to register what you see without being conscious of the laws of perspective. On the other hand, a basic understanding of these laws will enable you to draw complex subjects, such as townscapes, with more confidence.

The principle of perspective is that objects that are of the same size appear to diminish in size as they get farther away from the eye of the beholder.

When we say that a drawing is "out of perspective," we usually mean that certain lines have been drawn to the wrong angle. From where I am sitting as I write, I am looking through a window over the rooftops of the town toward the ocean. If I were to trace the outline of this directly onto the windowpane, it would become apparent how the roofs of buildings, which are of a similar size, are reduced in size toward the horizon.

THE EYE-LEVEL

Eye-level is the term used to express the height of the artist's eye from the ground – assuming that the lines are parallel to the ground and that the ground is flat. Lines that are above your eye-level are drawn down to the horizon or eye-level. Conversely, lines below are drawn up toward the eye-level. If you stand up or sit down, the eye-level moves up and down too.

Try this simple experiment. Stand in a large room and hold your pencil horizontally at arm's length. Look at the lines above your eye-level – the ceiling, for instance. Notice how the lines slope and try to judge the angle against the line of your pencil. If you then try to draw on a sheet of paper what you have seen – you are drawing in perspective.

All lines that are in fact parallel appear to meet at a point on the horizon we call the vanishing point.

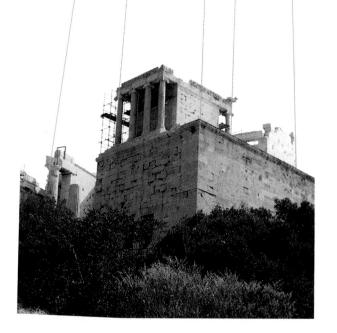

THE PICTURE PLANE

The picture plane is an imaginary transparent vertical screen between you and the subject. It is set at the distance from the artist where the drawing or painting is intended to begin.

When, for example, you think of buildings being parallel to your painting, they would also be parallel to the picture plane.

There are no straight lines in nature, and one should not apply the rules of perspective too self-consciously. Lines of construction are useful inasmuch as they contribute to the success of the finished work. Accuracy in drawing, however, has more to do with searching observation than with mere technical proficiency.

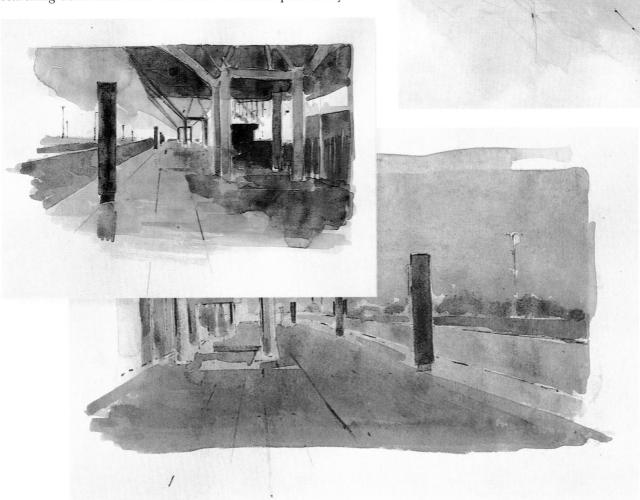

Three studies of the Stansted Airport Terminal in England designed by Sir Norman Foster. The basic shapes of contemporary architecture in a particular setting often demonstrate the principles of perspective very clearly.

How the Projects Work

he first part of this book has dealt with the essential techniques of watercolor painting. Learning how to handle techniques and understanding the particular characteristics of the medium is, of course, terribly important. Just as the novice pianist must necessarily practice the scales and learn chords, so the artist must be able to use a medium with fluency. Nothing, however, should deter the artist from starting to work from observation as soon as possible, and to do this you must be able to use techniques expressly to say what you have to say about a particular subject. If you concentrate too much on technique, you will never arrive at precision – if you concentrate on precision, you will arrive at technique.

Many artists using watercolors for the first time are fearful of making mistakes, but the greatest mistake you can make in life is to be continuously feeling you will make one! Almost all our faults are more pardonable than the methods we resort to to hide them. In the Project Section that follows you will see how three artists have approached the same subjects in terms of their own personal vision and technique.

around until he arrives at a particular balance of color, tone and linear description. His watercolors bear the imprint of someone who is more concerned with trying to respond to something seen momentarily than slavishly trying to follow some preorientated plan. His unique technique of first applying color with crumpled tissue, blotting areas off, and restating forms, allows greater freedom. There are times when the paintings may become overworked or don't dry in quite the way he had wanted, but he is essentially exploiting watercolor in its purest form – registering exquisite qualities of light in the process.

ANTHONY COLBERT handles the medium with a maturity that is very evident in paintings such as his Tuscany landscape (pages 134 and 135). He believes in doing preliminary drawings to gain a closer understanding of the subject and to provide an underlying structure to the painting. He gives careful consideration to the composition of his paintings — an aspect of painting that is all too often neglected by contemporary artists.

DEBORAH JAMESON uses the classic watercolor technique of line and wash. The preliminary drawings made in pencil are not simply filled in with color – she is able to produce the right balance between line and wash, so that they work together.

At the end of each project there is a critique that offers a brief appraisal of the work done. You may find yourself disagreeing with some of the comments or you might have some criticisms of your own. You might even feel that you could produce something better. If this is so, I will leave you with the following thought from Johann Wolfgang von Goethe: "We should talk less and draw more. Personally, I would like to renounce speech altogether and, like organic nature, communicate everything I have to say in sketches."

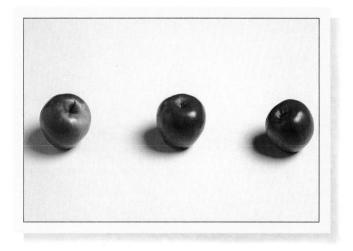

Still Life

THREE APPLES

"Still life" is the name we usually give to a grouping of objects on a tabletop. It is a subject about which we often have too many preconceptions, based perhaps on the kind of exercises that were required in the schoolroom or art class. The wine bottle, kitchen utensil and bowl of fruit against a background of draped curtain have become something of a cliché, no doubt derived originally from the 18th-century classical studies in the genre by Jean-Baptiste Oudry and Jean-Baptiste-Siméon Chardin.

The first thing to appreciate about still life, however, is that one has control over the way that the objects are disposed – and this in essence is the key to success. All good still-life paintings have an underlying unity of design. The apparently casual relationship between objects in a Cézanne still life, for instance, is often the result of a careful and sometimes prolonged consideration of the placement of objects in relation to each other in a given space. When you arrange and rearrange objects, you are trying to make them look "right" – in other words, you are responding intuitively to an instinct within yourself. The development of this visual judgment is critical to all aspects of drawing and painting.

A common beginners' mistake, in my view, is the selection of too many disparate objects. It is easy enough to collect together any number of objects that are interesting in themselves but, initially, my advice would be to "keep it simple." For this reason, I have selected just a few apples as a starting point for still-life painting in watercolor.

The apple has become a kind of symbol in the still-life paintings of Cézanne – he produced over a hundred compositions in which apples are the main subject. His aim was to "astonish Paris" with his apple still-life paintings, but he succeeded in astonishing the whole world by painting apples in a way that had not been attempted before and, in doing so, changed the whole course of the history of painting.

Cézanne's well known dictum, "everything in nature is modeled on the sphere, the cone and the cylinder," helps to explain his feeling for the underlying form and structure of all objects. He went on to suggest that if you could only master the depiction of these simple forms, it should then be possible to do whatever you wish in terms of drawing and painting from observation.

Artist • Ian Potts

YELLOW OCHER

CADMIUM RED

ALIZARIN CRIMSON

VIRIDIAN

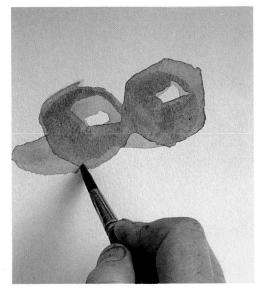

1 The basic shape of the fruit is established with a wash of Cadmium Red, modified by a touch of Alizarin Crimson.

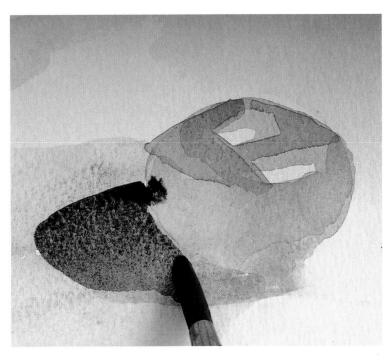

2 A wash of Viridian and Cadmium Red forms a shadow that echoes the shape of the apple.

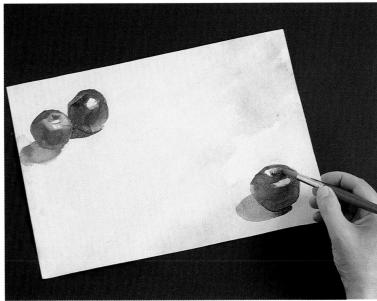

3 The modeling of the fruit is developed in terms of color and tone by applying successive layered washes.

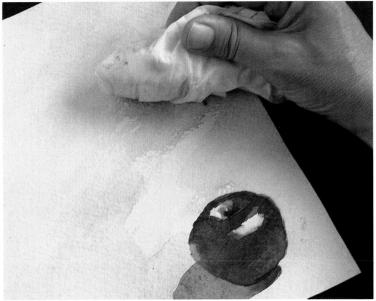

4 A pale blue-green wash mixed from Viridian and Yellow Ocher is laid over the whole sheet of paper excepting the highlights on the apples.

Artist • Anthony Colbert

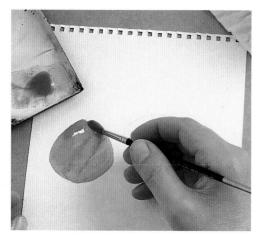

• The first red apple is painted with a large damp brush well-charged with paint at the tip using a mix of Cadmium Red and Cadmium Yellow.

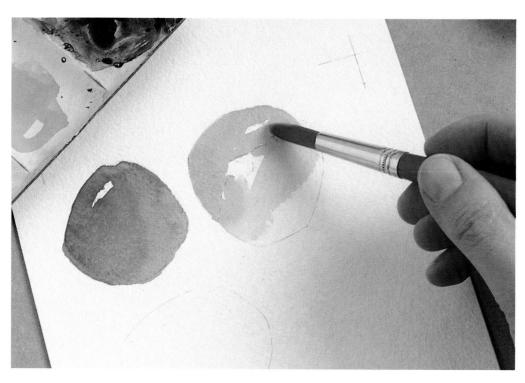

2 A graduated wash of Cadmium Yellow with a little Ultramarine is used for the second apple.

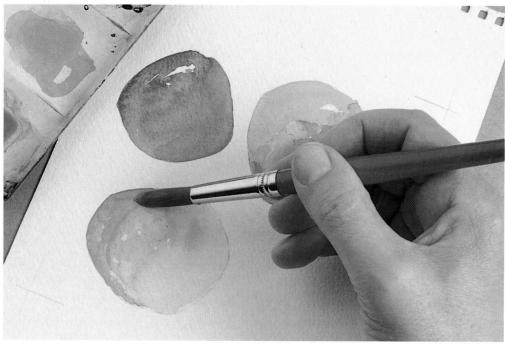

3 Red and yellow are mixed for the third apple with highlights lifted off while still wet. The silhouette of the second apple is completed with the same color.

Indigo

CADMIUM RED FRENCH ULTRAMARINE BLUE

4 A yellow-green wash completes the third apple highlights are lifted out with a damp brush.

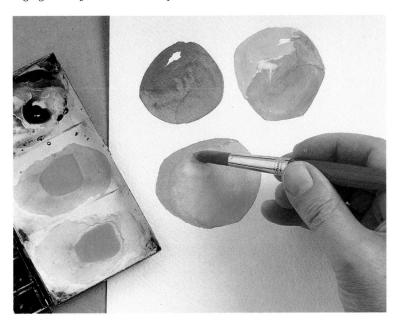

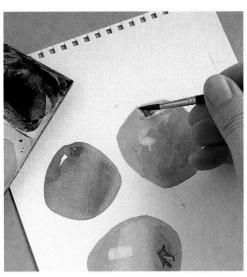

5 Shaded parts are added with a mix of red, yellow and blue. Stems are added with the same color.

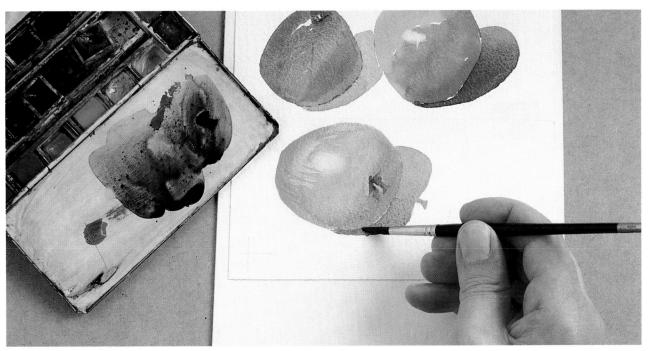

6 Cast shadows are produced with a wash of Indigo.

• Using a 2B pencil on a Waterford hot-pressed paper, the volume of the apples is hinted at, rather than overstated.

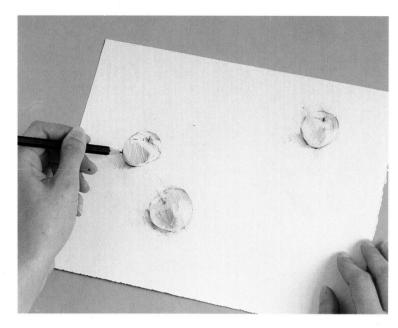

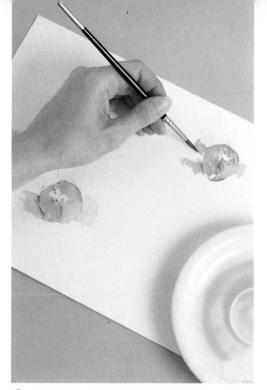

2 A dilute wash of Naples Yellow provides a base color that will influence the color of successive washes.

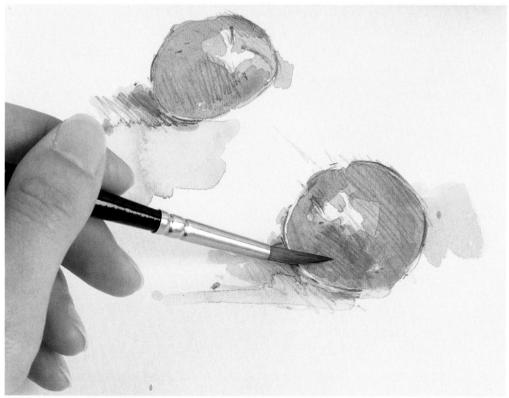

3 A wash of Cadmium Red is laid over the Naples Yellow on the apples to produce a warm but pallid tone.

NAPLES YELLOW

PAYNE'S GRAY

ALIZARIN CRIMSON

CADMIUM RED

A stronger wash of Alizarin Crimson is laid over the first two washes to produce the variegated color of the apple skin.

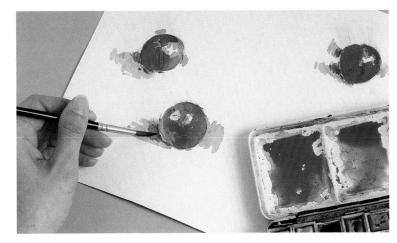

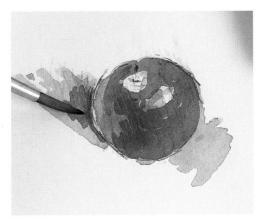

5 This detail shows how the same Alizarin Crimson is extended to the shadow as a base color for the darker tone to be added at the final stage.

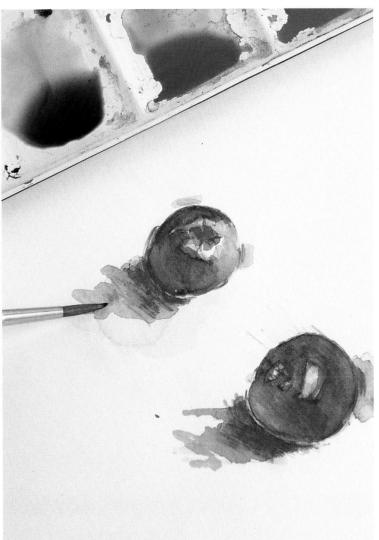

A final wash of Payne's Gray is used to lend expression to the modeling of the forms in terms of light and shadow.

apples are just a little overstated.

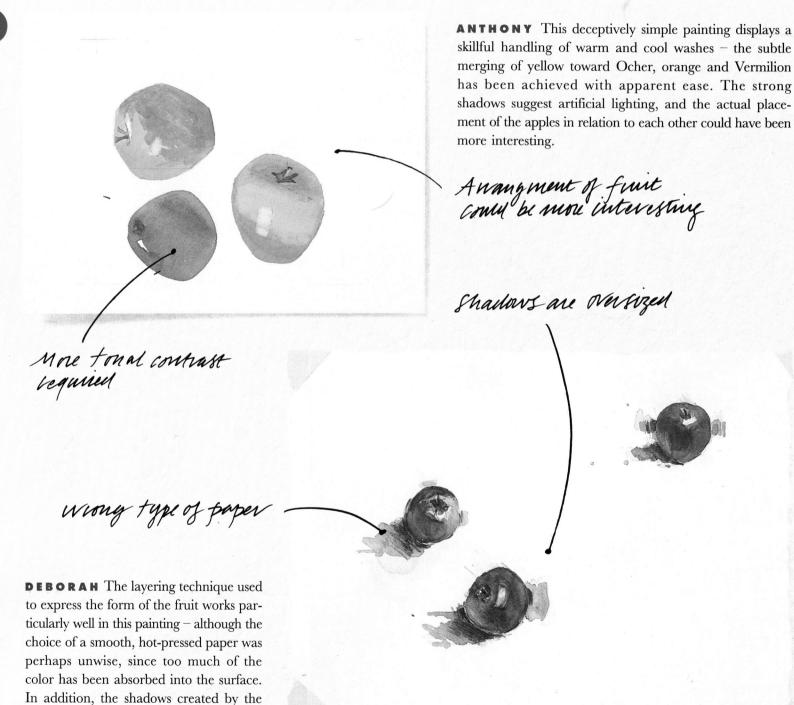

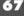

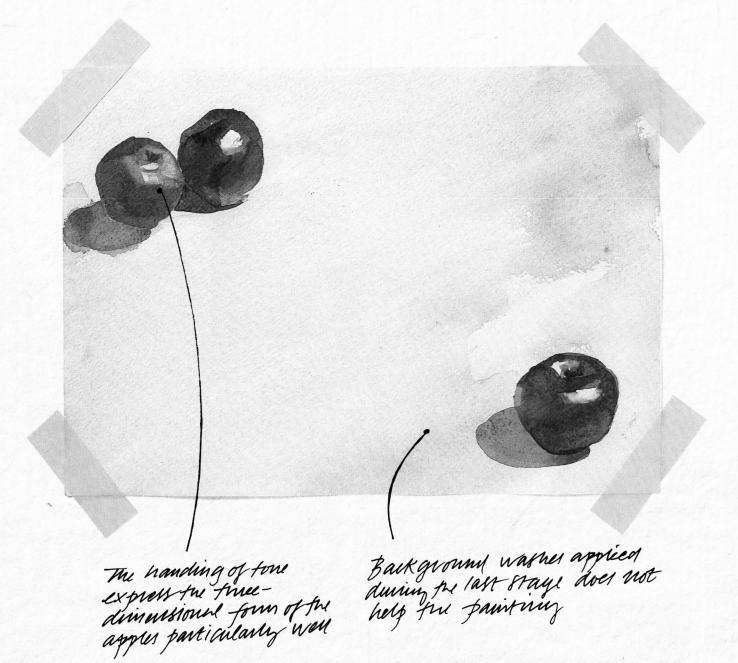

IAN There is no doubt that this painting worked much better in the early stages of development. A wash of yellowy-blue laid over the whole area of the painting at a later stage has the effect of leveling out the tonal contrast of the earlier stages. The coarse texture of the paper has been used effectively to enhance the sense of volume of the spherical forms of the apples.

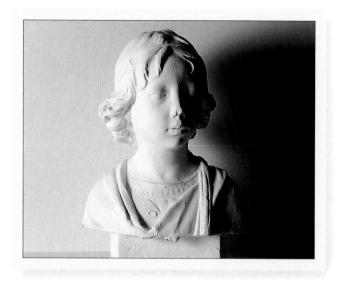

Light and Shadow

ANTIQUE HEAD

be strong and sharply defined or more subtle and barely perceived. In addition, with a graduated scale of tone from light to dark, we also need to perceive color that is modulated in warm or cool hues. Color and tone need to be harnessed together to produce a satisfactory painting. When working in watercolor, it is fairly easy to produce bold washes of primary color, but to produce a more subtle range of tone requires much more control.

For this project, a white cast of an antique head is seen against a white background. The aim of this project is twofold – to gain experience of controlling pale washes of color to render the subtle tones of light and shade and to learn to mix a wider range of warm and cool tints without adding body color (gouache).

From a basic set of watercolors, you will be surprised just how many shades of gray you can mix. Traces of Umber, Ocher and Cadmium Red produce warm tints; the blues – Cerulean, Cobalt

and Monastral with a hint of Lamp Black – produce cooler tints. It would be a useful background exercise to make your own chart of warm and cool tints – perhaps twenty of each with notes to remind you of the color combinations used in mixing each tint.

In a painting of this kind, the white surface of the paper itself plays an important part, as does the quality of light falling on the antique head. Because the head is cast in white, and the background is also white, the local color is neither warm nor cool. If, however, the light is a cold light, the resulting shadows will tend to be warm. Conversely, if the light source is warm then the shadows will be cool.

All of this may seem confusing at first but, with practice, you will begin to understand how color as color and light as light are combined in the adumbrated washes used to build up a painting. The more you paint from direct observation, the more you will begin to see shades of tone and hues of color that previously would have gone unnoticed.

Artist • Ian Potts

PAYNE'S GRAY

HOOKER'S GREEN

VIRIDIAN

Indigo

COBALT BLUE

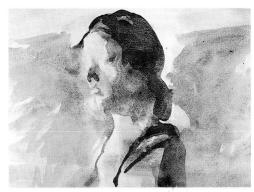

• The artist uses an unstretched sheet of Bockingford CP 300 gsm / 140 lb paper. The surface of the paper is dampened slightly and a background wash of Viridian mixed with a little Hooker's Green is laid in a very controlled movement with tissue. The wash follows the contours of the head. When dry, a stronger wash of the same color begins to define the features of the head and areas of shadow. Further adjustments are made by dabbing off some of the washes with a paper towel.

2 The modeling of the form continues with a No. 8 sable loaded with a mix of Indigo and a touch of Payne's Gray to produce a darker hue.

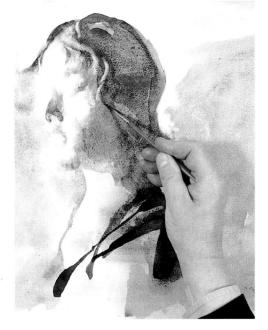

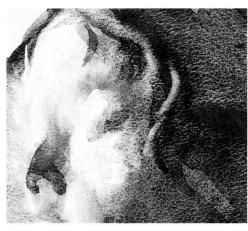

(3) (Detail) The paper is redampened and further washes are laid and lifted, in successive layers, until the balance of tone seems to be about right. The folds in the hair are dealt with at this stage, to suggest a sculptured low-relief.

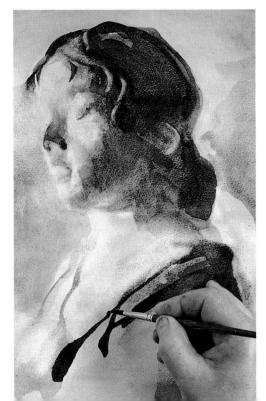

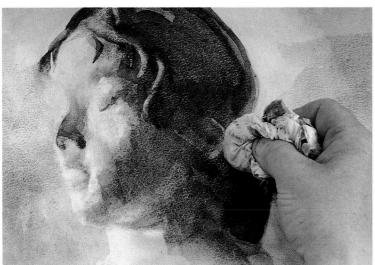

6 Certain passages of the painting are blotted off with a paper towel while the color is still wet.

An inky blue-black wash provides the darkest tone in the painting and intensifies the contrast even further.

Artist • Anthony Colbert

A wash of pale
Indigo is laid as a base
color for the painting,
using a Hake 3 inch,
and allowed to dry.
The wash is then
repeated over the
background, isolating
the shape of the
antique head.

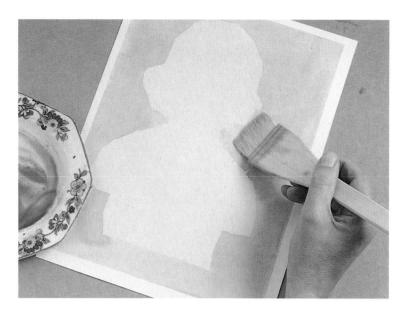

2 Pale shades are blocked in using the same color loaded onto a No. 8 sable brush.

3 The area of the cast shadow is dampened and a stronger mix of Indigo with a little Alizarin Crimson is brushed in.

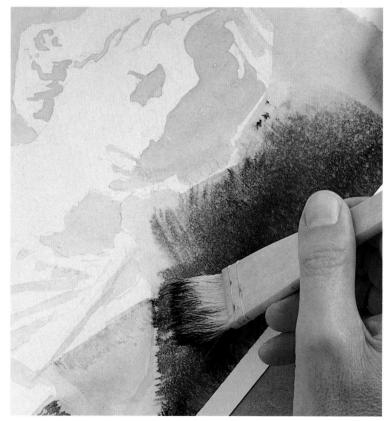

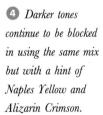

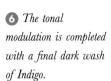

5 The same process continues – highlights are lifted from original washes with a clean, damp brush as necessary.

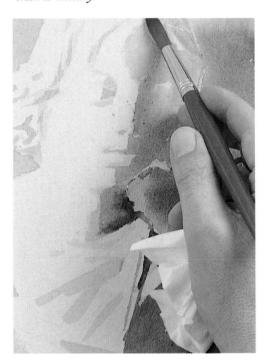

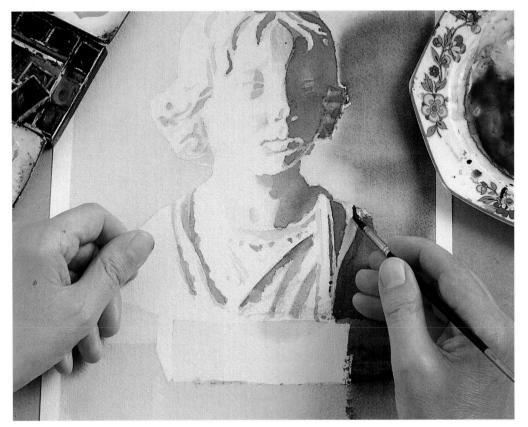

Artist • Deborah Jameson

72

• A Saunders hotpressed paper has been selected for this project. The basic proportions of the antique cast are tentatively stated with a soft pencil.

2 The drawing is further developed to establish tonal values.

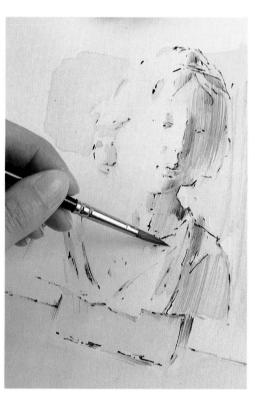

3 A much-diluted wash of Naples Yellow serves to heighten the contrast as it is laid over the drawing.

NAPLES YELLOW

PAYNE'S GRAY

LAMP BLACK

4 The folds of the form are picked up in Naples Yellow.

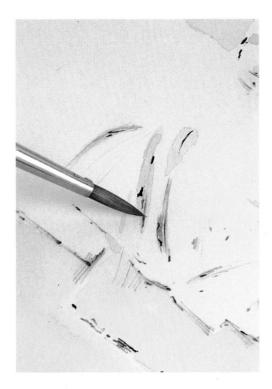

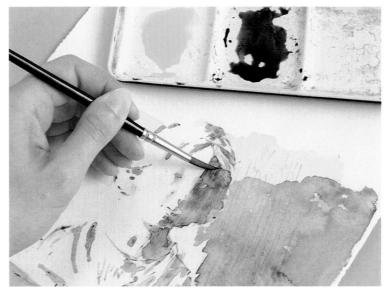

5 A granular wash of Lamp Black follows the form of the head and provides further contrast.

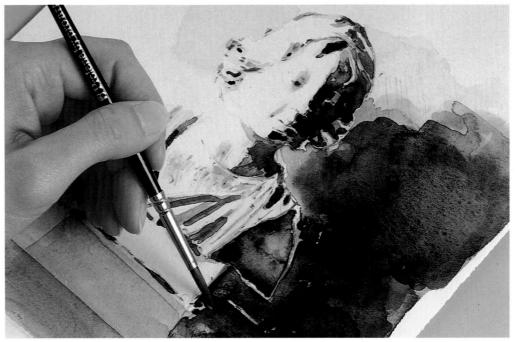

The darkest tones are produced by over laying a wash of Payne's Gray, which also adds a hint of blue to the areas of shadow.

Light and Shadow • Critique

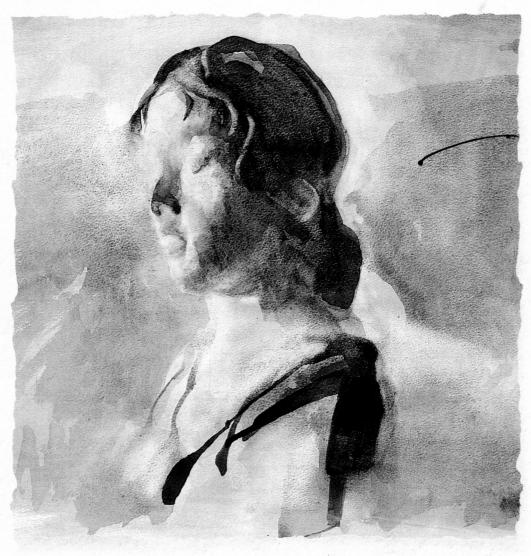

Overall Colom too

IAN This painting demonstrates just how much can be achieved with a few carefully coordinated washes that are closely related in tone and color.

The artist has resisted the temptation to overwork the painting by the addition of too much sharply defined detail. As in all the best watercolors, the painting retains the sense of suspended fluidity.

The color is perhaps a little too blue – a more restrained grayblue wash might have worked better.

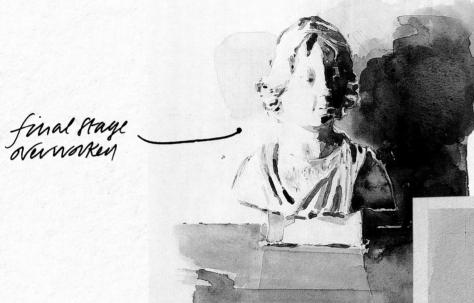

DEBORAH The color in this painting is of a warmer hue than the others — although, in the final stage, a near blueblack balances the warmth of the Naples Yellow. The artist has made good use of the white surface of the hot-pressed paper as an integral part of the image. My own feeling, however, is that it worked best at the second stage of development, when only a single wash of Naples Yellow had been added to the pencil drawing.

ANTHONY This painting makes good use of a range of soft and hard washes to create the illusion of a three-dimensional sculptural form.

It is clear that a considerable amount of premeditation on the part of the artist has been necessary to establish how best to employ washes with economy while at the same time suggesting modeling and graduation of tone from light to shadow. Again, it is perhaps too blue – and the white surface of the paper might have been used to better advantage.

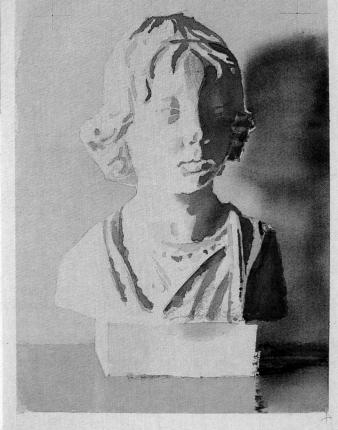

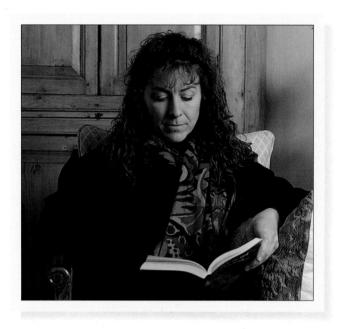

Portrait

GIRL READING

he experience gained from the first two projects can now be used to advantage in painting a portrait. Watercolor is a most suitable medium for portrait painting, since the best portraits are usually those which employ a few colors and closely related tones — paintings by Rembrandt (1606-69), for instance, are almost entirely monochromatic, relying as they do on dramatic tonal contrast. Bright primary colors tend to distract and dilute the tonal unity that necessarily directs our attention toward the expression of the person portrayed.

To talk of producing a "likeness" of someone refers not just to external appearances but also to the way that the particular expression and demeanor of the sitter can hint at character and personality. A good portrait must be more than mere imitative photorealism – it should, by sheer force of statement, uncover the emotional state of the sitter. In this respect, a rapidly executed

drawing or watercolor can sometimes be far more revealing than a prolonged study in oil painting.

Most people when sitting for a portrait will present a particular stance or gesture that betrays an aspect of their personality. The eyes, ears, nose and mouth are the primary organs of the senses and often provide a key to intrinsic character. The process of selection is all important – one needs to ask oneself, "what are the essential features that are unique to the person who is sitting before me and how can I best express those qualities, in terms of the medium I am using?"

Before starting a portrait, therefore, one should consider different viewpoints – profile, full-face or three-quarter. Is the subject best seen from a high or low vantage point? Should one stand two or six yards distant? Consider also the lighting and try to keep the background simple and free from extraneous detail.

Artist • Ian Potts

YELLOW OCHER

VANDYKE BROWN

COBALT BLUE

ALIZARIN CRIMSON

• Having first dampened the paper, the lightest tones of the painting are laid with tissue, wet-in-wet. When dry, the main form of the figure is blocked in with a wash of Cobalt Blue, which contrasts with the warmer tones of the background.

Painting onto damp paper allows the features of the portrait to remain in soft focus.

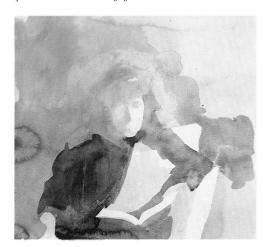

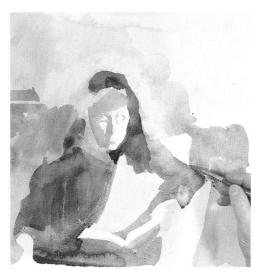

2 The darker tones of the hair are added with a wash mixed from Cobalt Blue and Vandyke Brown – producing a near black. The flesh tone is also heightened with a wash containing traces of Yellow Ocher and Raw Umber – the same color that is overlaid in the background.

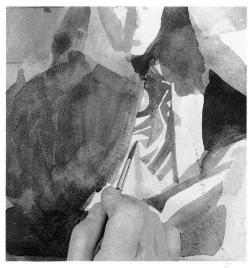

3 Using a No. 6 sable brush, details such as the pattern on the scarf are established. Other details are tentatively suggested with a few strokes of the brush—avoiding overstatement.

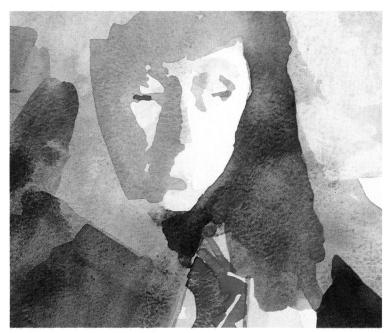

(Detail) Notice how the edge of the face is defined by a single wash of color.

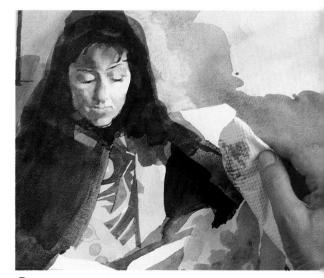

5 Color is lifted off with a paper towel.

Artist • Anthony Colbert

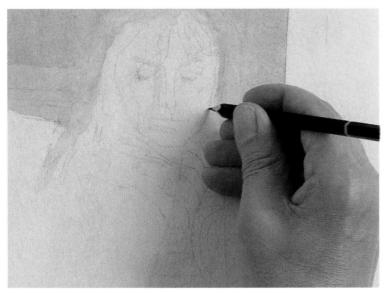

① A light wash mixed from Yellow Ocher and Cadmium Red is laid over the whole area and allowed to dry. The main features of the portrait are lightly penciled in.

2 An underpainting is established using washes of Burnt Sienna, Cadmium Red and Burnt Umber in varying strengths.

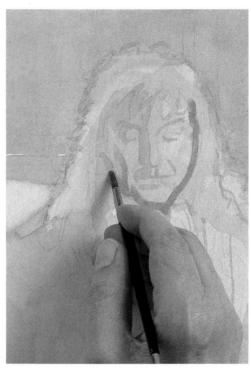

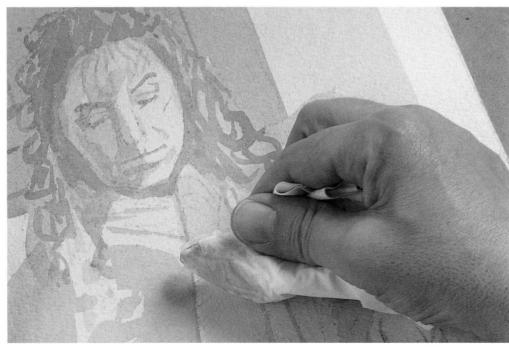

3 Some highlights are lifted out and other washes darkened to provide tonal balance.

YELLOW OCHER

CADMIUM RED

BURNT UMBER

RAW SIENNA

COBALT BLUE

Indigo

4 The bright primary colors of the scarf are painted in.

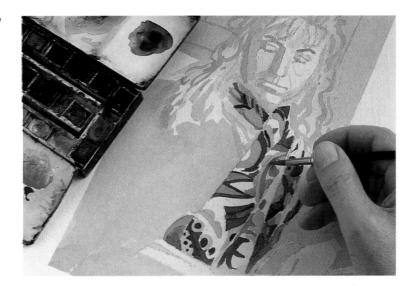

5 The hair and details on the face and hands are painted with Burnt Sienna. The same color is used for the details of paneling behind the figure. A strong wash of Indigo is applied to the coat and scarf.

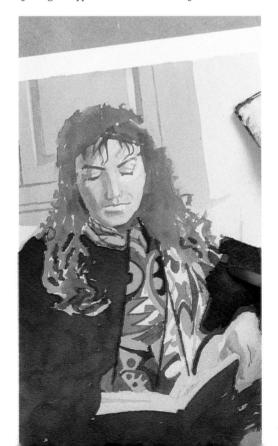

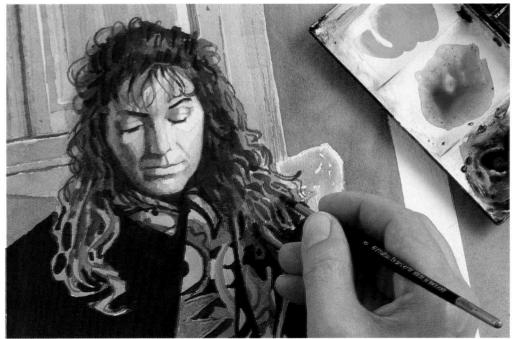

6 Using a No. 4 sable, fine details are added − the face is modeled with darker browns and flesh tints made from Yellow Ocher warmed with Cadmium Red. Cast shadows are produced with a mix of Burnt Umber and Indigo. In the hair, the light areas are

painted with Burnt Sienna, the darker tones with Burnt Umber.

A second wash is added to the coat and the wall is painted green to complement the warmer colors in the rest of the painting. • Having selected a profile view of the model, a preliminary drawing registers the main features of the pose.

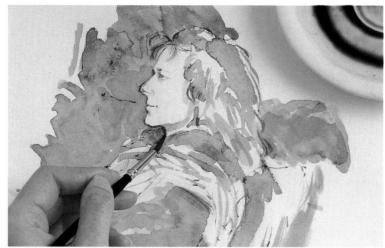

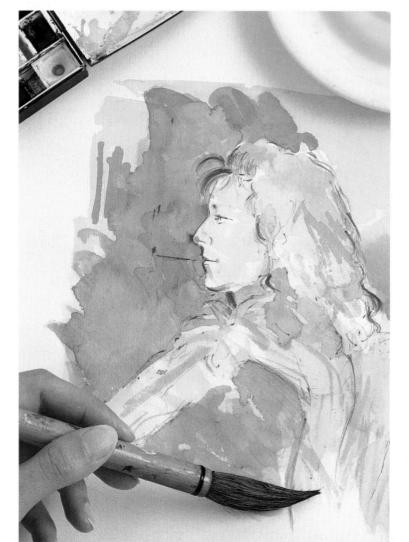

A wash of Payne's Gray follows the contours of the profile and works well as an underpainting for the washes to follow.

3 Using a broader Chinese brush, a wash of Naples Yellow neutralizes the Payne's Gray and provides the first flesh tint.

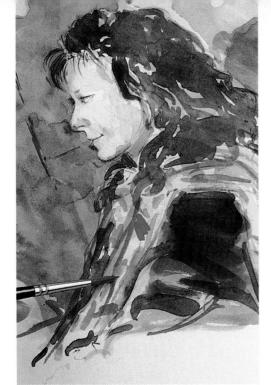

NAPLES YELLOW

PAYNE'S GRAY

VANDYKE BROWN

ALIZARIN CRIMSON

BURNT SIENNA

The main features are delineated with a No. 3 sable brush loaded with Burnt Sienna. The details of the scarf and chair are picked up.

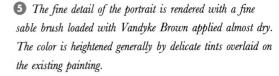

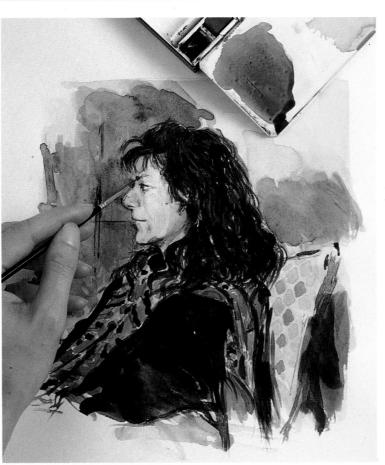

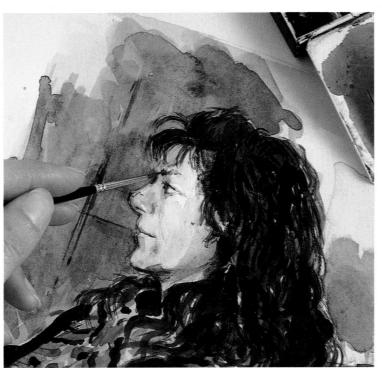

6 The drawing is refined with a fine sable brush.

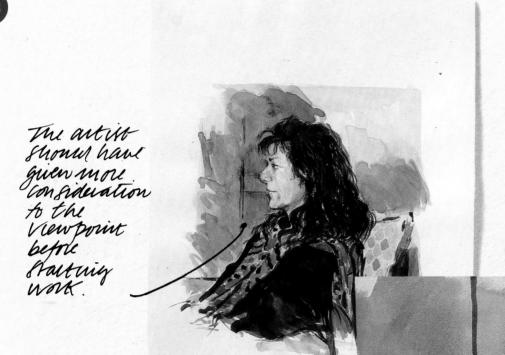

DEBORAH The artist has chosen a profile view of the model and this can be quite difficult to deal with in terms of the medium, since one must try to avoid creating an image that is too flat. The composition of this study is too symmetrical – it would have been better to include more of the foreground.

The delicacy of washes used on the features of the head are sensitive to the subject and work well on a hot-pressed paper.

The quality of light in the land stayes has been lost to some extent

IAN In the early stages of this painting, we saw how the artist was concerned with basic abstract interlocking shapes of color. It is well composed – notice, for instance, how a single vertical stroke of Burnt Umber on the left-hand side serves to balance the loosely ranged washes on the right. There is also an interesting interplay between hard-edged and soft washes of color.

The quality of light in the early stages has to some extent been lost – though not to any great detriment to the painting as a whole.

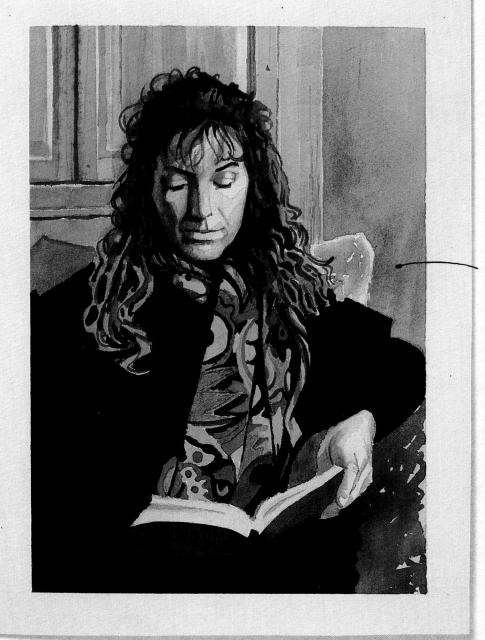

this painting has been overvorten in the final stage

ANTHONY This version of the portrait began as a monochromatic study in warm tints of Chrome and Ocher. It worked well in my view, in the penultimate stage – before the heavier tones were added to provide more definition. It is in the nature of watercolor painting that there are gains and losses at each stage. One might argue, for instance, that the addition of a darker tone to the coat enriches the color of the scarf and the introduction of a green wash in the background complements the warmth of the wood paneling.

Animal Study

"FLORENCE"

omestic animals have always been a source of interest to artists. The Egyptians, especially, produced magnificent murals depicting many varieties of birdlife.

Watercolor was used by Albrecht Dürer to make animal studies – who can forget his wonderfully controlled watercolor painting of a hare, painted in 1502. My favorite paintings of cats are the watercolors produced by Gwen John (1876-1939) and, more recently, by the Scottish painter Elizabeth Blackadder.

Cats are vain creatures and they love to pose – but unfortunately not always at the exact time you want to paint them! There are essentially two ways of dealing with their unpredictable behavior – either you can take into account that the cat is likely to move every few seconds and produce a kind of collage of rapid studies noting the movement itself or, alternatively, you can wait until they are more docile or asleep!

The cat we used in this project was quite indifferent to our attention but nevertheless tolerated our presence. Remember, even when you are painting an animal that is perfectly still, you should nevertheless try to paint it in such a way that suggests it is capable of movement.

YELLOW OCHER

PAYNES'S GRAY

VIRIDIAN

VANDYKE BROWN

• The paper is dampened and a succession of warm and cool washes are laid roughly following the form of the cat. The artist exercises control over each stage by laying the color with tissue, allowing some areas to dry and blotting off other areas where the color is too heavy. This process continues until the right tonal balance is achieved.

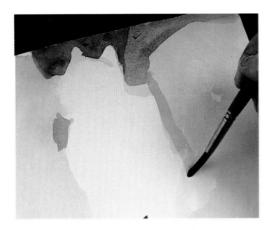

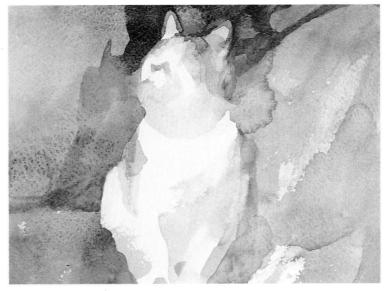

② A No. 8 sable brush is loaded with a wash mixed from Vandyke Brown and Viridian — this lends more definition to the contour of the cat, and begins to suggest modeling of the form.

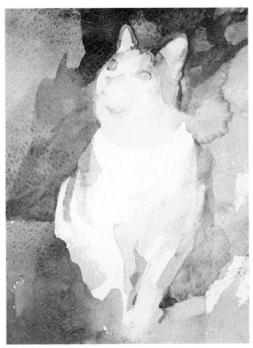

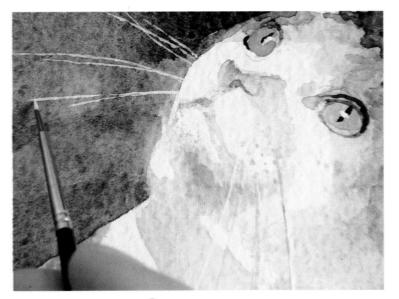

4 The final detail – the characteristic white whiskers are added using white body color sparingly on a No. 1 sable brush.

3 Greater definition is given to the head of the cat using a finer sable brush.

Artist • Anthony Colbert

• A heavily textured 300 gsm / 140 lb Bockingford CP paper was used. The whites are masked out and a rich mix of Cadmium red with a touch of Ultramarine is used to isolate the form of the cat and provide a base color for the carpet.

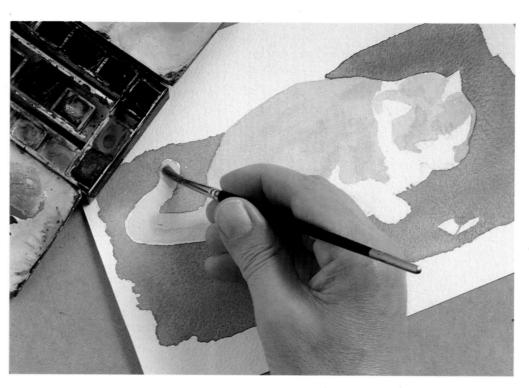

2 The light ginger color of the cat's fur is produced with a wash of Yellow Ocher and Burnt Sienna.

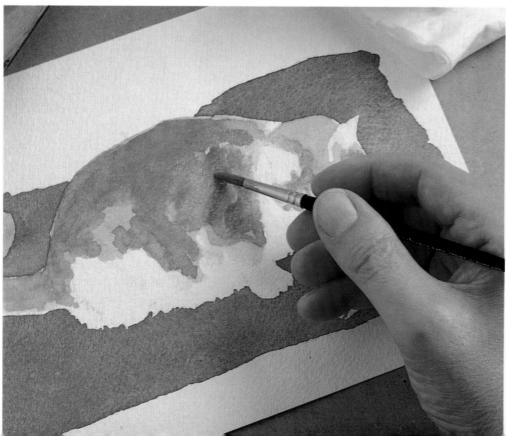

3 The surface of the paper is dampened and darker ginger markings of the fur painted with Burnt Sienna.

CADMIUM RED

BURNT SIENNA

PAYNE'S GRAY

FRENCH ULTRAMARINE BLUE

4 Even darker markings are produced with a wash of Payne's Gray. Soft edges are diffused with a damp brush.

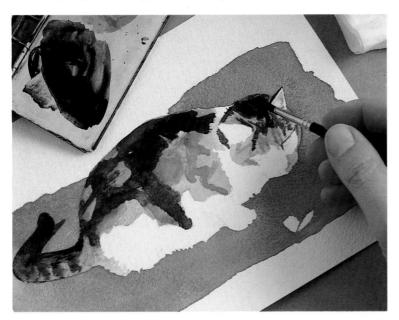

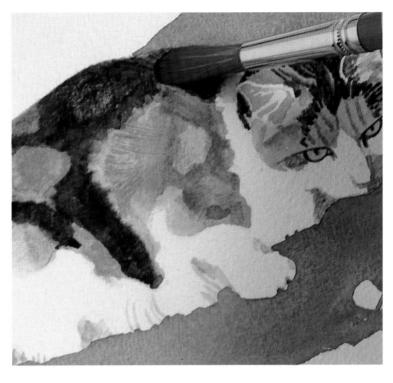

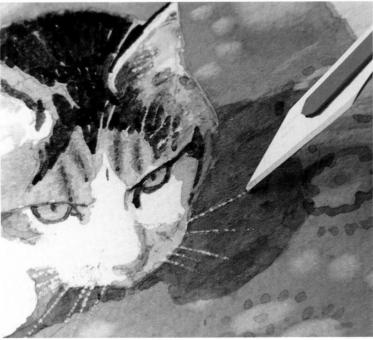

(5) With a dry No. 10 bristle brush, fur markings are added with a dry mix of Burnt Sienna and Yellow Ocher. The edges of the fur are softened with a clean, damp brush.

6 The decoration on the carpet is lifted out with a damp bristle brush and allowed to dry. Pale blue carpet decoration and cast shadows are added. Finally, the cat's whiskers are scratched out with a scalpel blade.

Artist • Deborah Jameson

① A rapid sketch is made directly onto a Saunders rough paper using a 3B pencil. A few washes of blue-black help to establish the form of the cat.

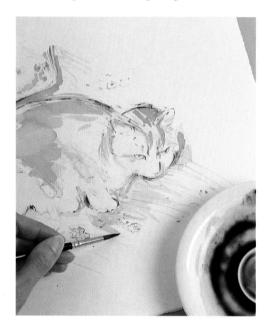

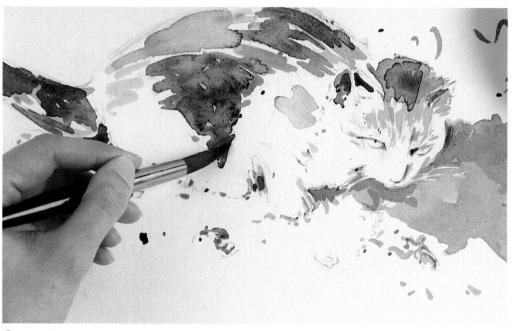

2 Areas of shadow are rendered with further layered washes of the same blue-black.

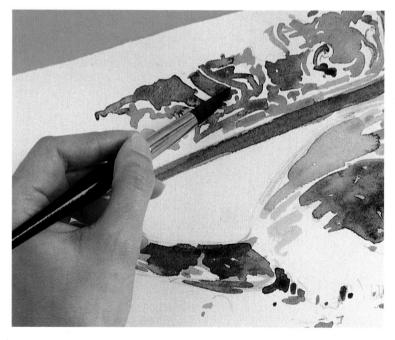

3 Blue-black is also used to pick out the detail of the chair cover.

INDIAN BED

CADMIUM RED

PAYNE'S GRAY

Indigo

4 The red pattern of the carpet is introduced with a wash of Cadmium Red and Indian Red mixed in equal proportions.

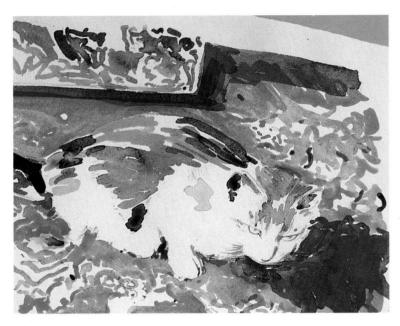

5 The detail shows how the pattern of the carpet is hinted at with a few deft strokes of color.

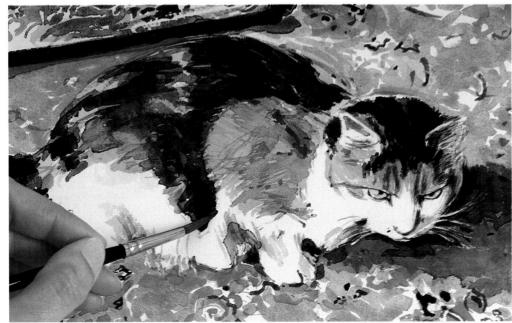

6 The tonal balance is adjusted by further washes. Dry brushwork produces details such as the animal's fur and picks up here and there the intricacy of the patterned carpet and chair.

Each layer of color is allowed to dry thoroughly between each stage.

Animal Study • Critique

DEBORAH This is a fairly lucid handling of the subject, with all the elements gelling together quite well. The artist has managed to render detail without allowing the image to become stilted — the animal looks capable of movement, rather than being just a slavish Natural History illustration.

The animal is not for stilledit looks capable of marment

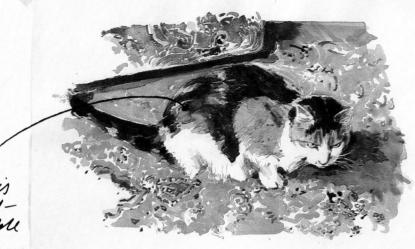

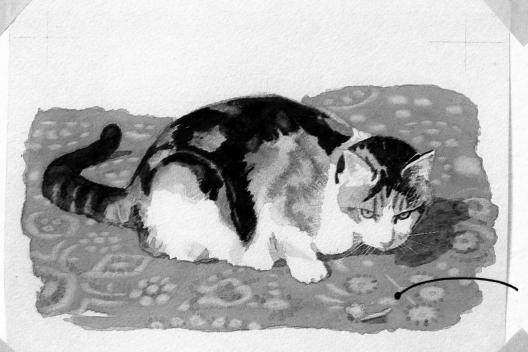

ANTHONY This study is distinguished by the richness of the washes used. The textural qualities of the cat's fur have been handled well in terms of the medium used – a combination of wet-in-wet, broad dry brushwork and fine detail.

In the final stage of the painting, the added pattern of the carpet tends to distract a bit too much from the main form of the cat. That could have been handled in a more selective way, or perhaps by making the tone of the carpet slightly darker.

Tone of carper could be signed darker

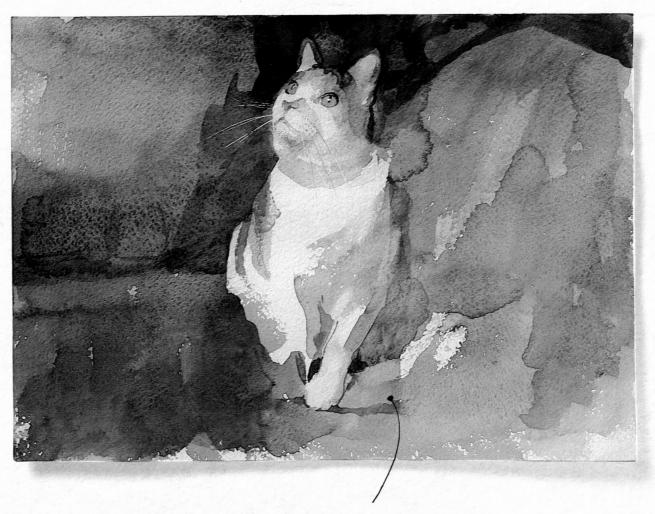

The main form hus been 10st to some extent

IAN A considerable amount of risk-taking has been involved in producing this painting – the artist's technique of applying and lifting off washes in successive strokes demands concentration on maintaining a balance between lost and found shapes and a predetermined knowledge of the effect that one wash will have when

laid over another. There have been some gains and losses in this painting – in the early stages it worked quite well in an overall way. In the final stage, however, the head of the cat is quite convincing, but the main form of the rest of the animal seems to have been lost.

Interior

FARMHOUSE KITCHEN

hat I am after is the first impression... I want to show all one sees on first entering a room... what my eye takes in at first glance" (Pierre Bonnard, 1867-1947). One of the problems of attempting to produce a painting of one's own immediate domestic environment is overfamiliarity. Bonnard had the ability to paint things freshly – as if he were seeing things for the first time. I find that one way of overcoming this problem is to cut a rectangle or square from a sheet of cardboard in order to view different parts of the room. By using a framing device in this way, a variety of compositional ideas emerge. Most artists taking up watercolor do so because it is a portable medium that can be used for painting landscape. The domestic interior might be thought of as a winter or "bad-weather" subject - when van Gogh was prevented by the *mistral* from painting outside, he turned to painting flowers and the humble arrangement of his few pieces of bedroom furniture. Yet we now think of these paintings as being among his most successful.

The types of interior compositions that often work best are those where you can see from one room into another, and perhaps to a window beyond. There is an anticipatory element in such paintings that prevents them from being dull. For the Dutch artist Jan Vermeer (1632-75), the domestic interior was a subject of primary interest. He employed all kinds of visual devices to lead the eye toward the solitary figures that appear in his compositions. Checkered floor patterns, carpets and drapery, furniture, musical instruments - every element in his compositions served a particular purpose in supporting the central theme of the composition. As with still life, you have a degree of control in the way things are arranged. Shapes near and far need to be linked together in a way that is visually satisfying. It sometimes helps to make a series of preliminary sketches in pencil to sort out the basic formal elements of the composition. That will help you to decide what should be included and what should be excluded before you begin painting in watercolor.

Artist • Ian Potts

GAMBOGE YELLOW

YELLOW OCHER

RAW UMBER

BURNT SIENNA

A VANDYKE BROWN

VIRIDIAN

Indigo

• The artist works directly with a broad flat sable brush onto dampened paper. Careful consideration is given to the main source of light through the open doorway and the way that the light is distributed on the objects on the table. Hues of color merge wet-in-wet and cool into warm.

3 (Detail) A wash mixed from Cadmium Red and Yellow Ocher is applied with a piece of folded tissue.

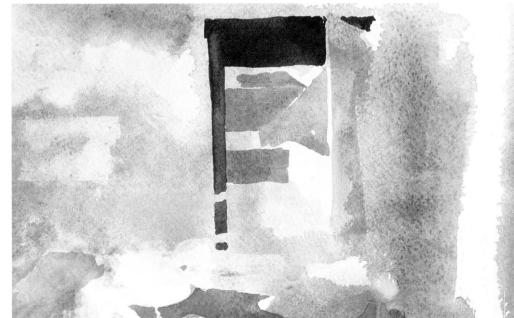

2 The dark frame of the doorway is carefully blocked in with a wash made from varying proportions of Vandyke Brown, Indigo and Yellow Ocher. The same wash is diluted for shadows around the door and table. The various pots and fruit bowls are picked up with Burnt Sienna.

4 A darker wash of Vandyke Brown mixed with Raw Umber provides the shadows to the objects on the table.

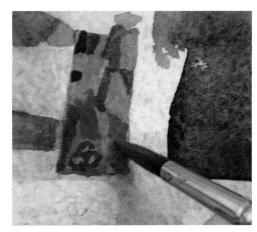

5 Final details, such as the colored scarf on the chair, are added using a fine sable brush.

Artist • Anthony Colbert

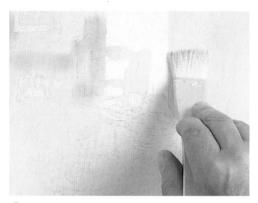

① Light objects on the table, such as the cheese cover, knife, plate and flowers, are masked out with masking fluid. A wash of pale Cadmium Yellow covers the whole of the interior. Lights are lifted with a dry brush and shadows are indicated wet-in-wet with Yellow Ocher.

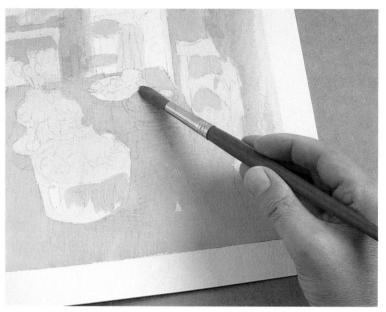

2 A second warm wash of Burnt Sienna is added – particularly on the table and door.

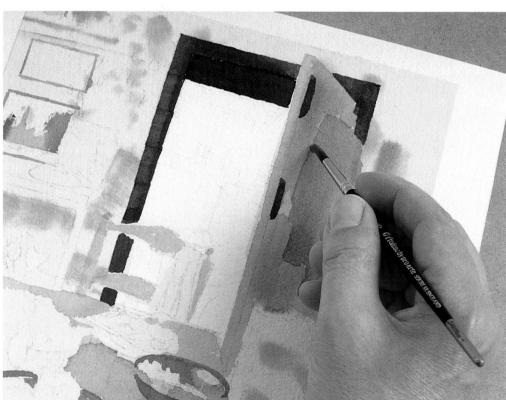

3 Tones are established with browns and olive greens.

CADMIUM YELLOW

YELLOW OCHER

BURNT SIENNA

BURNT UMBER

BER CADMIUM RED ALIZARIN CRIMSON . COBALT

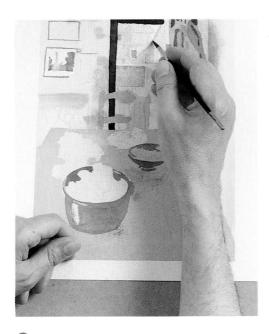

4 A range of washes closely related in tone are applied for shadows behind the door. Pale, cooler washes, used for the exterior, contrast with the warmth of the interior colors.

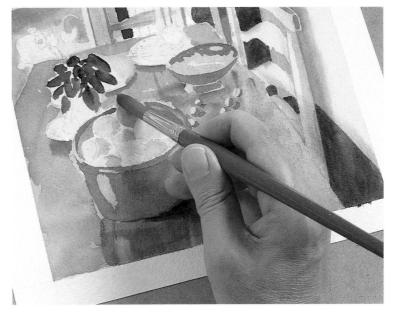

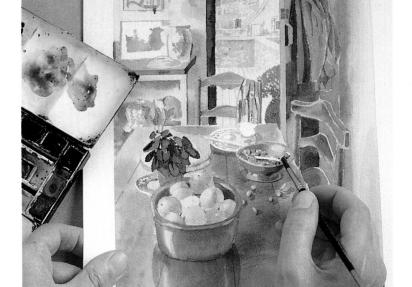

G The painting is given greater depth by the addition of cast shadows on the table and other surfaces and recesses.

Reflections and highlights are lifted out with a dry brush.

added to flowers, fruit and to other objects on the table. Three brushes were used for this painting – a Hake ³/₄ inch, a Prolene 20 and a No. 8 sable.

Artist • Deborah Jameson

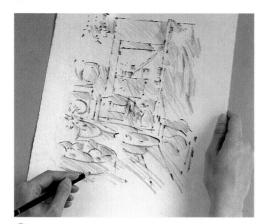

• From this viewpoint, the eye is led across the kitchen table, through the open door toward a distant farmhouse. The main forms of the composition are denoted with a soft pencil on a Saunders rough paper.

2 A pale wash of Chrome Yellow separates the interior from the exterior and provides a base color for successive washes.

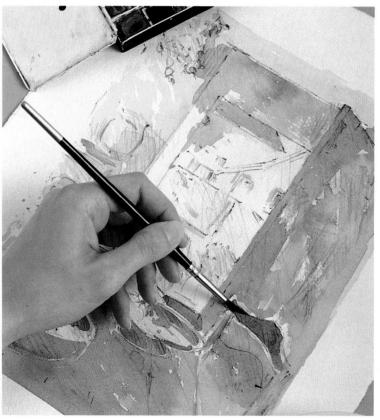

3 A wash of Burnt Sienna is applied to the table and door and serves to underpin areas of shadow.

CHROME YELLOW

NAPLES YELLOW

PAYNE'S GRAY

BURNT SIENNA

ALIZARIN CRIMSON

Indigo

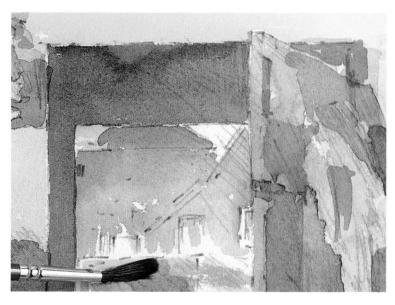

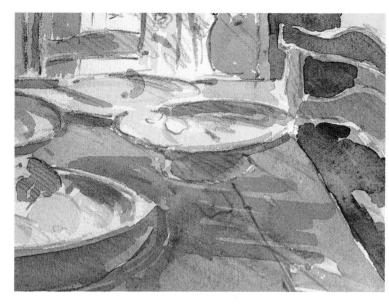

Darker hues are applied to enhance details in the painting. The tonal balance is built up using layering techniques.

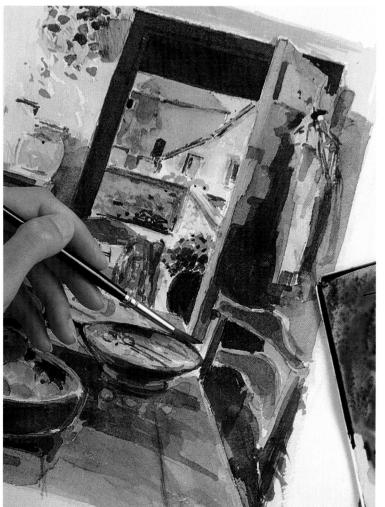

A stronger wash of Payne's Gray is used to suggest the color of the flint buildings seen in the distance.

6 The same wash is used to follow the form of objects on the table, the door frame and shadows created by the door itself.

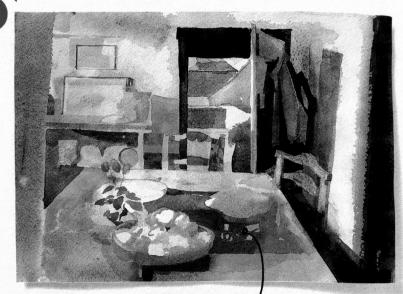

IAN A well-composed painting that worked to particular advantage in the early stages, when the quality of light filtering through the doorway illuminated the objects on the table.

Something of this has been lost in the final stage when the tones have become more even, as further darker washes have been laid over the more tentative washes of the earlier stage.

The painting nevertheless possesses a strong atmospheric quality, which is conducive to the subject.

Good composition

Tones conce have been darker to produce more contrast

ANTHONY The artist has obviously given a great deal of thought to the composition of this painting – he has deliberately distorted the perspective in order to invest the painting with more interest. The painting is distorted in the same way that a wideangle lens would reproduce the scene, to suggest a greater feeling of being in the room, looking down at the table and out through the open door.

The doorway itself provides a useful device for separating warm and cool hues. The main criticism of this painting is that there could have been more tonal contrast on the interior, which in turn would have made the exterior appear even more brilliant.

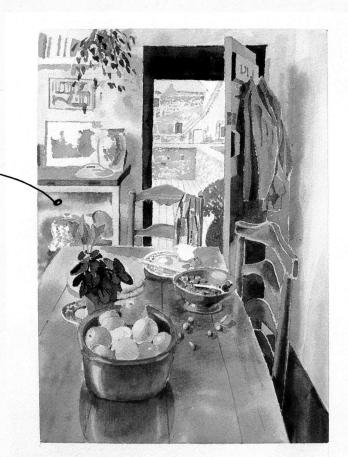

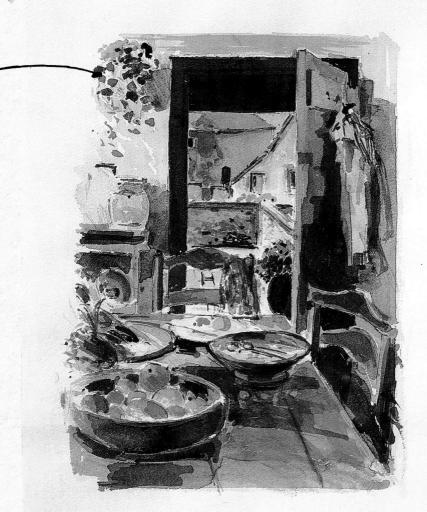

DEBORAH Layered washes are handled well on the interior part of the painting but, as with the other two paintings, there is insufficient contrast between internal and external tonal values.

In terms of composition, the various elements are perhaps too evenly disposed – a different eye-level might have produced a better result.

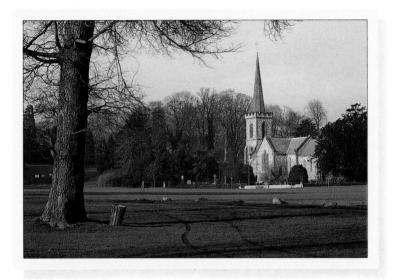

Architecture

PARISH CHURCH

The indeterminate nature of landscape demands some point of reference – there are, of course, natural phenomena such as outcrops of rock, waterfalls, rivers and great forests. But more often than not, we look for some kind of reference to humanity. Farm buildings, isolated dwellings and churches can provide a point of interest in an otherwise featureless scene. Medieval builders gave great consideration to the selection of a suitable site for a building; moreover, they used locally quarried stone. This resulted in a much closer affinity between artificial and natural forms. In the United States and other countries of the "new world" there is often a fine tradition of timber-framed haylofts, barns, farmhouses and weatherboarded churches.

Architectural subjects demand contrast; the three-dimensional qualities of a building are best rendered by clearly defined areas of light and shadow. It is important to consider the building in relation to the other elements within the field of vision – trees,

roads and walls disposed at different levels lend a sense of scale to the painting and provide visual links between the various parts of the composition.

If your chosen subject happens to be a fairly ornate example of vernacular architecture, such as a castle or mansion with a great many windows and intricate stonework, the temptation to register every detail is bound to lead to failure. From whatever distance you are positioned from your subject, try to see the whole scene in terms of basic interlocking shapes. Be selective, by hinting at the textural quality of bricks, shingles and surrounding foliage. The success or failure of the painting will depend to some extent on the particular balance between form and structure. In watercolor, that means the parity between washes, which describe the broader areas of color and tone, and the linear detail, which is expressed either by an underlying drawing or by dry brushwork.

YELLOW OCHER

BURNT SIENNA

BURNT UMBER

HOOKER'S GREEN

REEN FRENCH ULTRAMARINE BLUE

VIRIDIAN

ALIZARIN CRIMSON

1 A base neutral wash mixed from Burnt Sienna with a touch of Ultramarine is laid with a wad of tissue onto a sheet of dampened Bockingford paper. When dry, further somber colors are layered over the woodland area adjacent to the church.

Pale washes of Viridian are laid over the sky area.

A wash of French Ultramarine Blue, Burnt Umber and Yellow Ocher produce a pale green for the grass in the foreground of the scene.

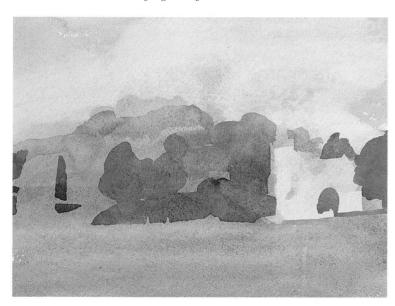

3 The tree on the left-hand side of the composition is loosely painted with a No. 8 sable brush loaded with Umber for the bark, which in turn is overlaid with Alizarin Crimson and Burnt Umber for shaded areas. Branches are added with a few deft strokes of the same color.

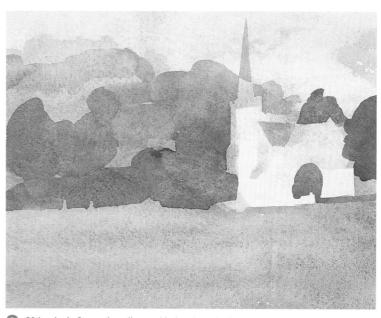

2 Using both fine and medium sable brushes, details such as the steeple of the church are added as a single wash of Gray Ocher. The tones of the distant foliage are heightened with layered washes.

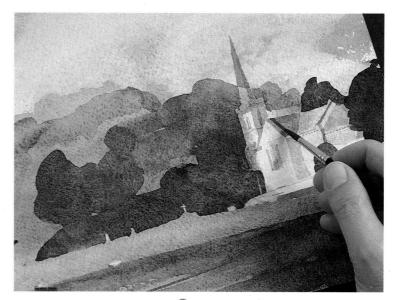

• Architectural detailing is added to the church with a fine brush.

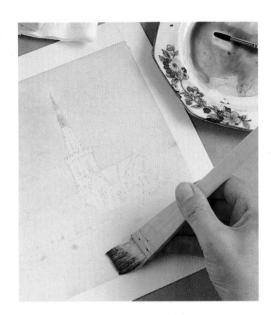

• Having traced down a fine line drawing of the main outlines of the composition, the church together with sapling stalks, tombstones and the church wall is masked out with masking fluid. A pale wash of Ultramarine Blue mixed with a little Alizarin Crimson provides an overall warm blue tone. The wash is made from top to bottom with a 13/4 inch Hake.

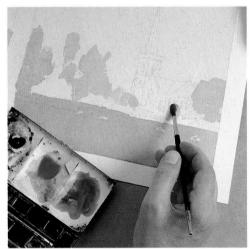

2 The lightest green is laid – mixed from Hooker's Green and a touch of Ultramarine. The wash is applied to the evergreens and to the foreground.

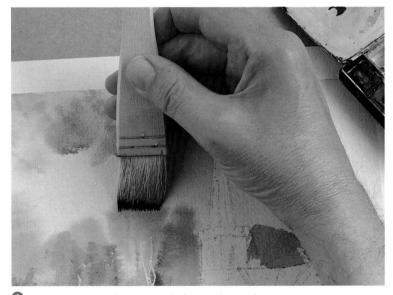

3 Using the same brush, the paper is dampened to produce a semicircle of tree haze behind and beside the church. A soft mix of Burnt Umber cooled with Indigo is dropped onto the dampened patches with a Hake that is almost dry. This effect produces a soft, warm gray haze that suggests fine twigs and distant tree forms.

NAPLES YELLOW

YELLOW OCHER

BURNT UMBER

CADMIUM RED

ALIZARIN CRIMSON

HOOKER'S GREEN

N FRENCH ULTRAMARINE BLUE

Indigo

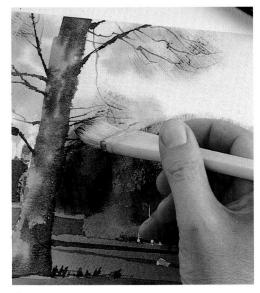

4 Yellow Ocher and a touch of Burnt Umber are mixed together to produce a fairly strong warm tone for the tree trunk. This is overlaid with more Burnt Umber and Indigo with a dryer Hake, dragging the brush vertically across the wet trunk. At the same time, the brush is twisted slightly to throw out branches from the trunk into the dry paper. More detail is added to paths, shadows and trees, with a No. 4 sable.

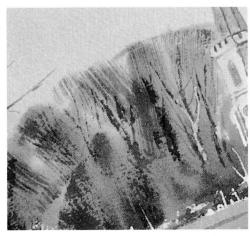

5 The masking fluid is removed. The light and dark areas of stonework on the church are added with varying strengths of Naples Yellow and gray.

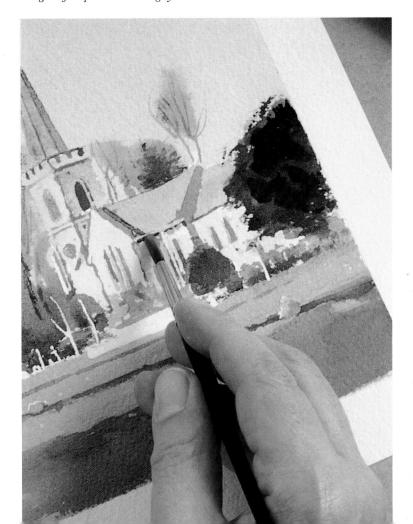

6 Architectural detail is hinted at with a fine brush loaded with gray.

Artist • Deborah Jameson

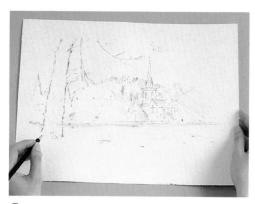

• The main forms of the composition are deliberately understated in pencil to allow the brush to produce the main drawing.

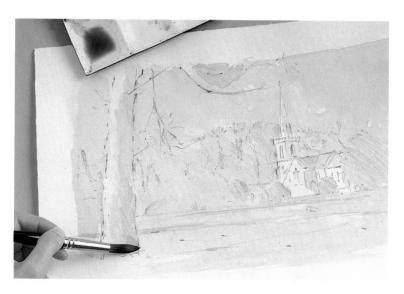

2) A pale wash mixed from Alizarin Crimson with a touch of Payne's Gray provides a neutral base for the painting, and serves to isolate the light on the façade of the church.

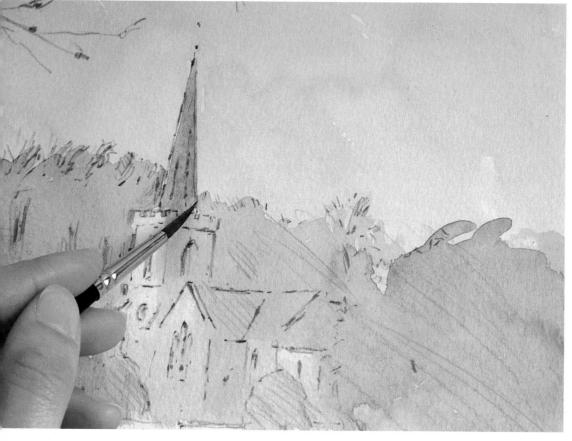

3 A single wash of Raw Sienna covers all the area of the painting except the sky. While still wet, the wash is lifted from the front of the church with a dry brush, to produce a paler tint.

YELLOW OCHER

HOOKER'S GREEN

PAYNE'S GRAY ALIZARIN CRIMSON

RAW SIENNA

A green-umber wash, which is much darker in tone from the previous washes, is applied to define contrasts of light and shadow in the painting.

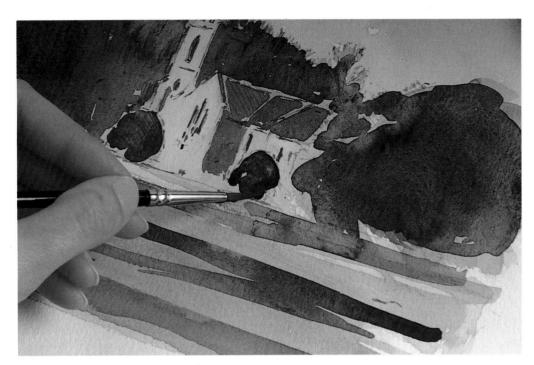

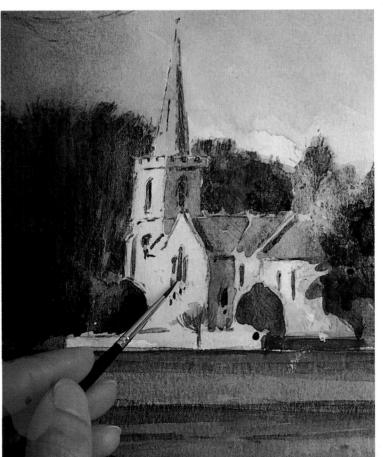

Successive washes of green-brown and violet are applied wet-in-wet to foliage. Hooker's Green is applied to the foreground and a paler wash of turquoise overlaid in the middle-distance. Finally, the architectural details and branches of trees are picked up using a fine dry brush technique.

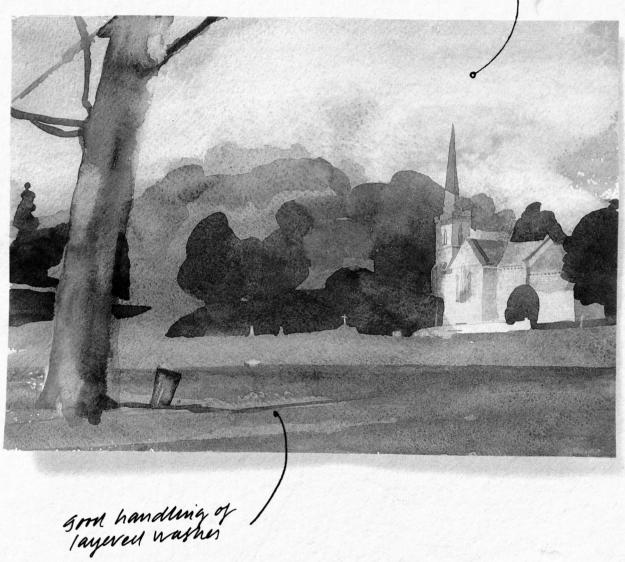

IAN The apparent complexity of this scene has been successfully broken down into simple blocks of color. The artist has exercised great restraint in selecting a few closely related washes to convey the essential atmospheric qualities of a fall day.

The somber colors of the distant woodland contrast with the warmth of color used for the church itself.

The wash laid over the sky is almost Viridian and, in my view, quite unsuited to the subject.

washes have been too

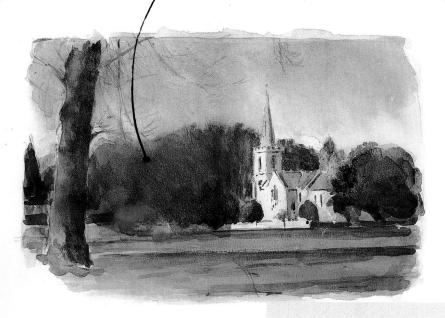

DEBORAH

There is a pervading atmosphere in this painting, which is suited to the subject and shows a good use of the medium. There has been much reworking of washes, which has to some extent affected the transparency of the color and produced an overall dullness.

good feeling for light

Composition too stilley

ANTHONY There is a pleasant feeling of light in this painting – helped by the pale wash mixed from Ultramarine with a little Alizarin Crimson. Masking fluid has also been used effectively on the church.

One has the feeling, however, that the artist was too conscious of technique in this painting, albeit skillfully employed.

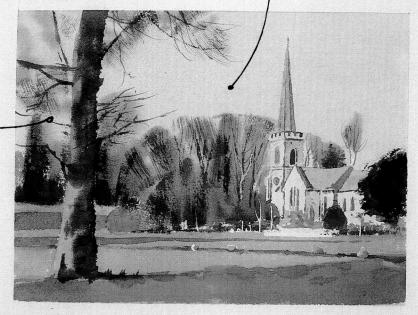

Townscape

RURAL FRANCE

n air of indolence pervades these backstreets of a small town in the Lot region of southwest France. The buildings are all built from locally quarried stone, which seems to generate the heat of a hundred summers or more. And it is the time of day when most inhabitants are to be found in cool, shuttered rooms, and only watercolorists and sleeping dogs are out in the streets! The very lack of human presence stirs the interest; as our field of vision narrows, we begin to focus on details such as doors and windows, and the lure of the unsuspected makes us want to walk around corners and explore alleyways. The iron gate, slightly ajar, beckons us towards the darker recesses of the house in front of us.

Ancient towns and villages rarely conformed to a grid-like plan, but rather grew together as a random sequence of spaces and enclosures. The problem for the artist confronted by such a scene is somehow to convey the sense of place by bringing together textures, juxtaposed planes, color and contrast, and by exploring the character and individuality of each building. The honeyed hues of the stone can be contrasted with cooler areas of shadow. Everything needs to be broken down into simple planes of light and shadow, and the verticals of the building linked and joined by horizontal paths of light and shade. Details need to be registered selectively – the texture of a wall hinted at, perhaps, or the particular shape of a window described precisely. Where houses are grouped closely together, it may be difficult to find a suitable vantage point, but it is always worthwhile to view the subject from different levels and distances before settling down to paint.

Artist • Ian Potts

INDIAN RED

RAW UMBER

3 The area around the central doorway is developed

with a series of washes of Viridian and Burnt Umber.

BURNT UMBER

VANDYKE BROWN

VIRI

VIRIDIAN

Indigo

PAYNE'S GRAY

① Using a swab of moist tissue, a wash of Indian Red is laid over the whole area of the paper with the exception of the sky and a patch of light in the middle distance.

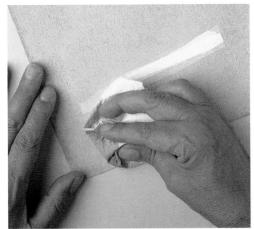

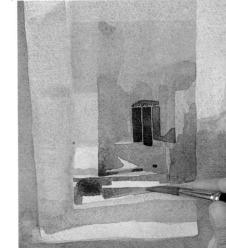

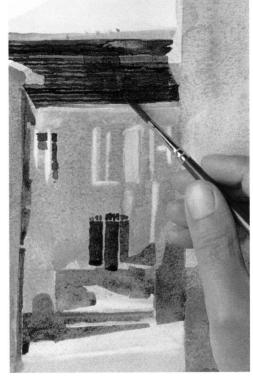

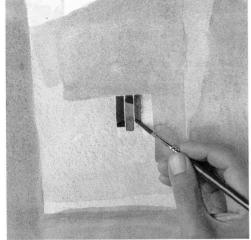

2 Further washes of Indian Red added to the central building and to the wall on the right. A wash mixed from Raw Umber and Viridian is brushed broadly over the building on the extreme left, and to shadow in the foreground. A few slats of Payne's Gray are overlaid on the doorway of the central building.

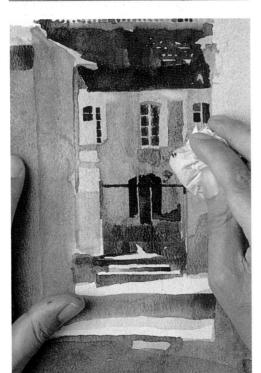

The shapes of the window frames and shutters are lifted out of the first wash using a wet Q-Tip.

Darker washes of Indigo are added to the roof using a No.6 sable brush.

5 Further washes are added and immediately softened with a wet tissue. Details such as the gate are suggested as well as the darker recesses of window.

Artist • Anthony Colbert

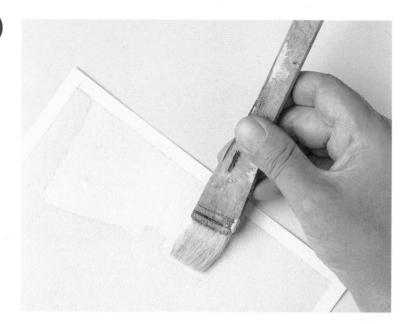

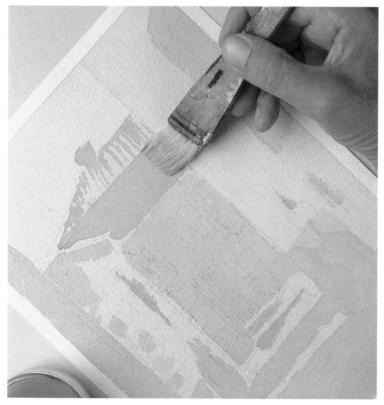

• An overall wash, mixed from varying proportions of red and blue, with a touch of Naples Yellow and Raw Sienna is laid using a Hake brush. When dry, the windows and shutters are masked out, and the wash is repeated except in the area of the sky.

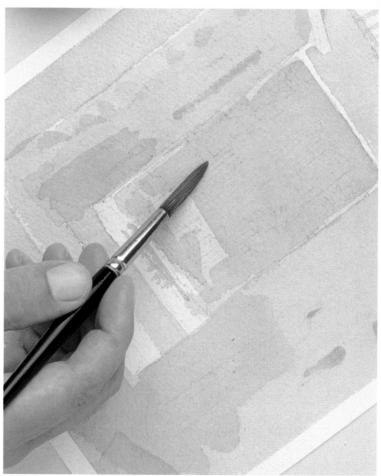

3 A warmer wash, mixed from Naples Yellow and Raw Sienna with a touch of red, is laid on areas of walls in sunlight.

2 The same wash is strengthened in the areas of shadow and on parts of the building structure.

CADMIUM RED

RAW SIENNA FRENCH ULTRAMARINE LEAF GREEN

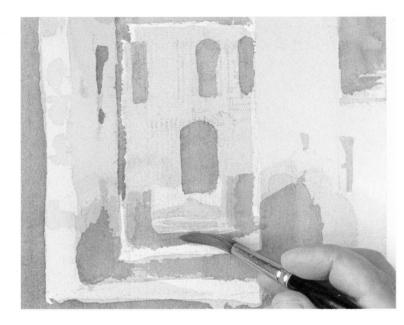

5 Using a 1-inch Dalon brush, windows are darkened, as is the main entrance to the central building. Masking fluid is removed at this stage from windows and shutters. A No.4 sable brush is used to dot in shaded ends of pantiles.

4 The original wash is again strengthened to indicate dark shadows and shaded areas. Suggestions of windows and steps are blocked in. A Cadmium Red wash is overlaid on the second wall on the left and the same wash stippled on roof tiles.

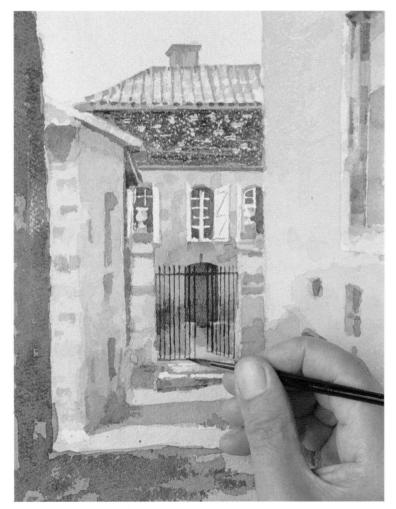

6 The forecourt is darkened using a dilute wash of the original applied color with a Hake brush in a onestroke action, so that the pigment settles downwards. Details such as railings are added, as well as greenery. A texture is scraped on the roof tiles with a flat blade.

Artist • Deborah Jameson

2 A warmer pale wash mixed from Sahara Yellow and Naples Yellow is laid over most of the surface area except the sky, windows and shutters, and patches of light between buildings. A 2-inch Hake brush is used to produce an even tone.

• The main divisions of the composition are tentatively registered with a soft pencil. A pale wash of French Ultramarine with a touch of Carmine Red is laid over the sky and in recesses of the buildings.

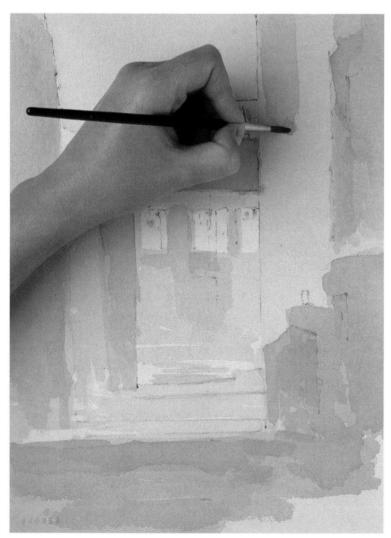

3 The warmer hues of the stone walls are suggested with washes of Gamboge Yellow and Chrome Yellow using a No.5 sable brush.

NAPLES YELLOW

GAMBOGE YELLOW

Снгоме YELLOW

OCHER

CARMINE RED ULTRAMARINE

VIRIDIAN

AUBERGINE

4 Areas of shadow are strengthened with a wash mixed from Aubergine, Lamp Black, and mauve.

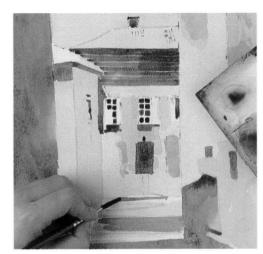

6 Greater contrast is created by adding a dark wash mixed from Terre Verte, Lamp Black, and Viridian. This is added to the wall on the left, areas of shadow on paths, and in recesses of door and windows. Texture is added to walls using a stippling technique. Details such as the iron gate are picked out using a fine No.1 sable brush.

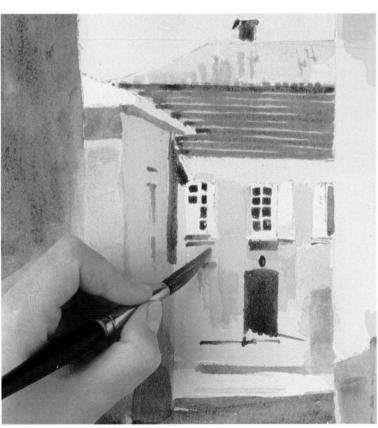

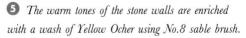

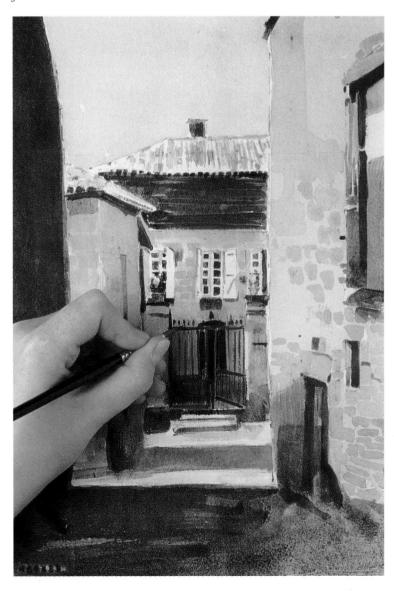

114

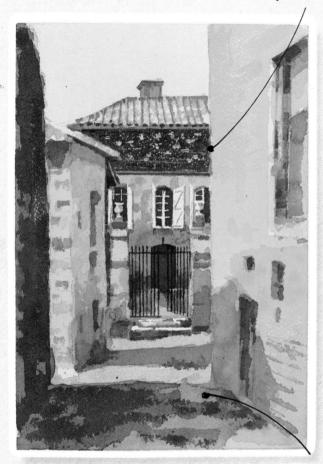

ANTHONY The artist has obviously decided to use colors in a "high key" to evoke the brilliance of the day. The interaction between broadly-stated washes and selected fine detail is handled well, as is the treatment of surfaces in terms of texture, such as the roof pantiles and the irregular stonework of the buildings.

Tonally, the work is rather too even; some might feel that more contrast could have been created by intensifying shadows, particularly in the foreground. Needs more Contrast **DEBORAH** The contrast between light and shadow, cool and warm hues work well in this painting. Compositionally, however, it is perhaps too symmetrical. This might have been resolved by the artist standing further back or moving to the extreme left or right alleyway. The washes have tended to become too opaque in certain areas, such as the façade of the central building.

Wash are too rpage

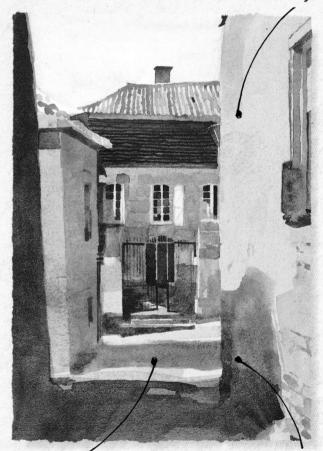

Contrasts work wen Compositure.
is tro
symmetrica

color of stone

115

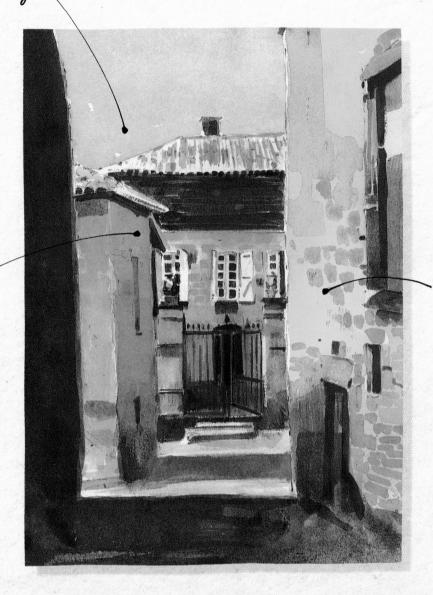

Washes one well handley

IAN The broad treatment of washes is handled confidently and convincingly in terms of the subject. The artist has, in my view, struck the right balance between planar relationships and selected descriptive detail.

The color of the stone is perhaps too red and tones too even. My own feeling is that everything worked better earlier. Of course, it is easy to say this with hindsight, but difficult to recapture the freshness of a painting in its earlier stages.

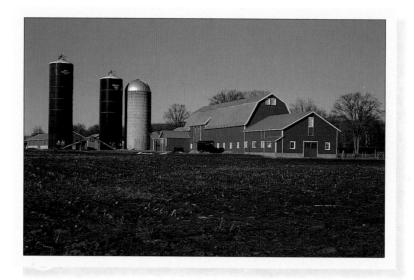

Landscape

RED BARNS

here are now few parts of our planet that people have not had some part in shaping – forests have been cleared and replanted, valleys flooded to create reservoirs, the land plowed and tilled to grow crops and boundaries constructed to enclose pastures, roads and railroads built to link small communities to towns and cities. In fact, the whole history of human development is imprinted in the land itself.

Nostalgia is often the driving force behind landscape painting – our attachment to a vanishing past is generally held to be a mark of our inability to see the shape of the present. Most contemporary landscape paintings, therefore, refer to the past rather than the present. Much depends, of course, on where one happens to be living – if, for example, you happen to be living in a suburb of Melbourne, Australia, or on an American farm such as the one chosen for this project, you will have a totally different outlook to an artist living in northern Europe. An artist usually works best on his or her own "patch" – although sometimes it is necessary to travel around the world to discover simple truth.

Wherever you happen to live, you will need to take account of the particular terrain and geology of the region and to discover how best you can express those particular qualities in the mediuum of watercolor. Again, climate will be a very important factor — the mood and atmosphere created by the equable climate of northern Europe will be quite different from the clarity of light that can often be experienced in many countries situated in the southern hemisphere.

Choosing the right time of day and the right season for your subject is also important. It sometimes happens that we see a place under particular conditions of light, at a certain time of day, only to discover when we return to paint the scene a day or so later that it looks quite different. If we are patient, however, we will discover exactly the right time of day that is most suited to the subject. In a warm southern climate, the light may be too intense except in early morning or toward dusk, whereas the intrinsic qualities of a northern mountainous region might look best in rain or snow.

INDIAN RED

RAW UMBER

BURNT SIENNA

COBALT

Indigo

BURNT UMBER

VIRIDIAN

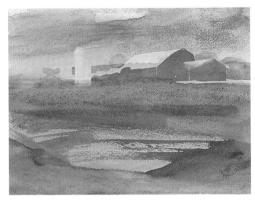

A warm neutral wash is laid with tissue on dampened paper and blotted off again in the area of the sky, before being allowed to dry. A grainy wash of Viridian mixed with Cobalt Blue is applied over the sky and blotted off on the silos and barn roofs. The rich red color of the barns is expressed with a single blocking shape of Indian Red and Raw Umber.

The earth color extends from the middle-distance to the foreground.

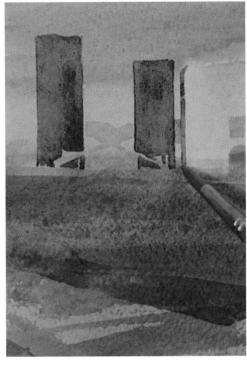

2 The dark, cylindrical shapes of the silos are painted in with a No. 8 sable brush, loaded with a wash made from equal proportions of Cobalt Blue and Vandyke Brown with a touch of Indian Red. The darker tones are dragged over the field area with a dry brush.

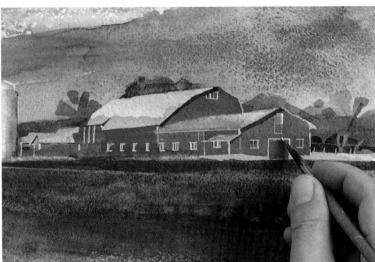

3 Highlights and shadows are introduced with a fine sable brush.

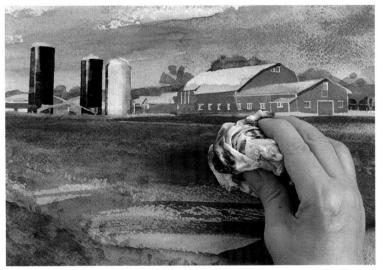

4 The earth color is enriched with another wash mixed from Burnt Umber, Vandyke Brown and a touch of Indian Red.

While still wet, certain passages are blotted off with a paper towel.

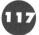

Artist • Anthony Colbert

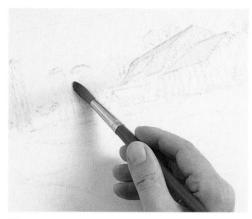

• The artist decided to paint the subject at dusk in order to heighten the drama of the composition. He began by making a rough preliminary study in charcoal. After lightly drawing in the main features of the composition, the roofs, tops of silos and crops are masked out. A warm wash of light red is added to the skyline — diffused upward with a damp brush.

2 The surface of the paper is moistened and the sky brushed in with a mix of Prussian Blue and Indigo. This in turn is made lighter toward the skyline with a damp brush.

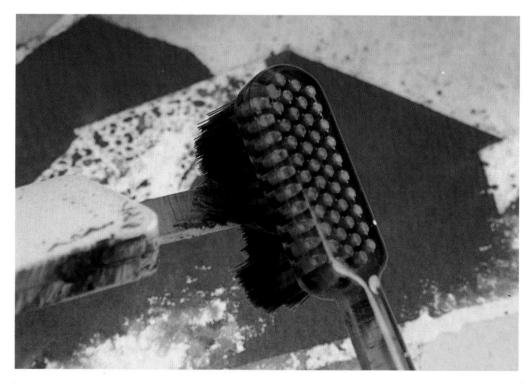

3 The sky is masked out with masking film, leaving the silos and barn walls free. Light red is brushed and spattered into the barn walls and Naples Yellow used as a base for the crops.

NAPLES YELLOW

CADMIUM RED

HOOKER'S GREEN

Indigo

PRUSSIAN BLUE

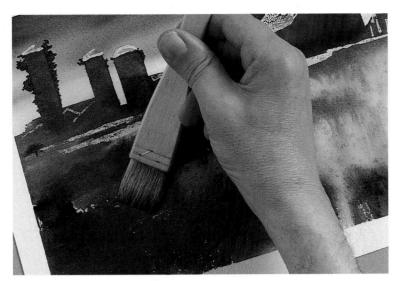

4 A mixture of Prussian Blue and Indigo are added quickly with a Hake – the board is rocked slightly to bring out the grain of the paper. Indigo is spattered using a toothbrush to add texture.

5 The tone of the barn is moderated with a wash of dark Prussian Blue and Indigo.

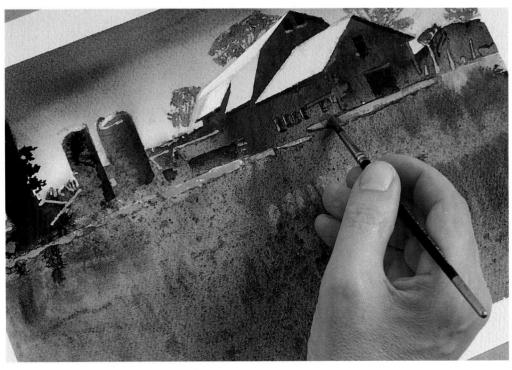

All the masks are removed. The skyline and tree forms are added. Posts and roof angles are reduced with cool Indigo. The top crop line is indicated with a wash of Hooker's Green. Finally, a blue-black ink is used to darken the silo on the extreme left and to suggest the tree behind.

Artist • Deborah Jameson

120

1) A Bockingford CP surface paper has been selected. The outlines of the barns and silos are registered with a 2B pencil.

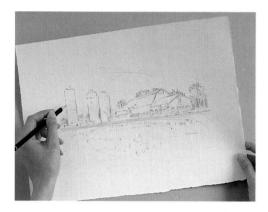

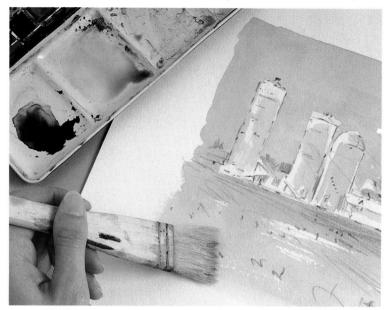

2 French Ultramarine is mixed together with just a touch of Alizarin Crimson to produce the first overall wash.

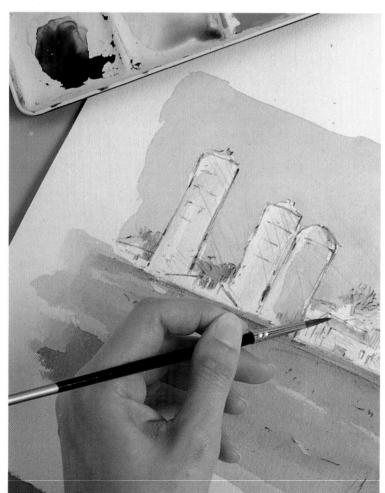

3 Burnt Sienna and Raw Umber produce the next wash to be applied, which in turn produces a green-gray color when laid over the existing blue.

BURNT SIENNA

RAW UMBER

BURNT UMBER

INDIAN RED

French Alizarin Crimson Ultramarine Blue

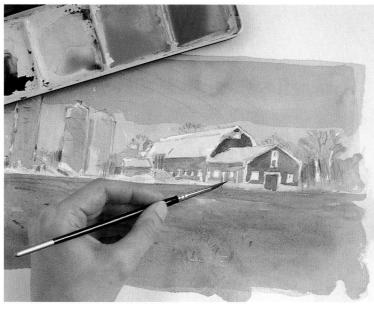

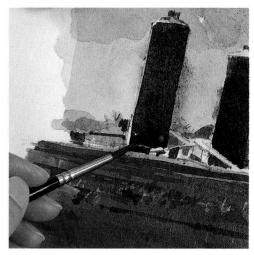

5 French Ultramarine is used to provide tonal contrast and, when used dryly, to pick out detail on the buildings, trees and field.

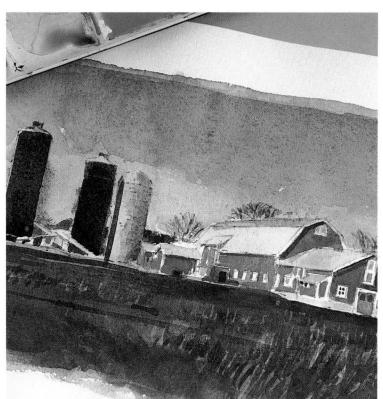

6 A darker blue-black tone is added to the silos.

Good unity of some

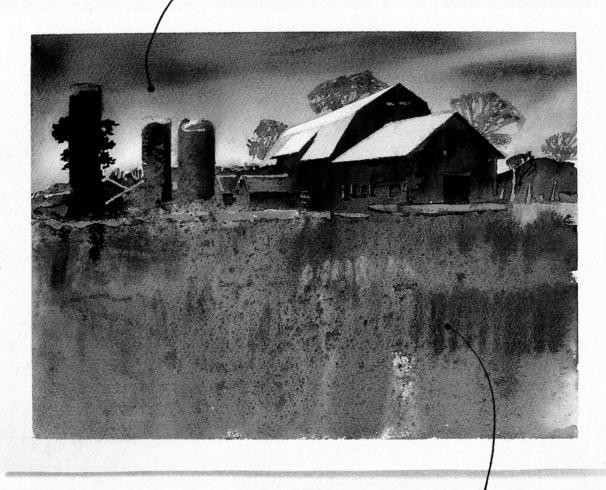

ANTHONY In this version, the artist has elected to paint the scene at dusk, when color values are radically different — especially on the barns where the local color is reduced by shadow. Colors are much more muted and unified at this particular time of day, so the image tends to read as a single, monochromatic statement.

Wet-in-wet techniques have been used to good effect in the foreground and provide a foil to the stark silhouettes of the barns and silos.

wetin-wet tedinique used to advantage

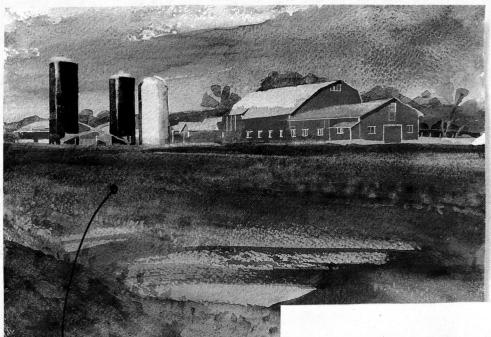

IAN The rich terra-cotta color of the barns supplements the blue-green wash used for the sky.

Softer washes of red-umber and redbrown occupy almost two-thirds of the picture plane. The sentinel silos on the left-hand side of the painting serve to punctuate a predominantly horizontal composition. One has the sense that the artist has enjoyed painting a scene that has allowed him to exploit such unusual color relationships.

Rich colow contrast between sky, barns and earth.

DEBORAH This is a fairly "matter-of-fact" rendering of the subject, which makes no attempt to seduce the viewer with rich color or with the techniques used.

In terms of composition, everything is too evenly balanced, and it might have been better to include more of the foreground or, conversely, more of the sky.

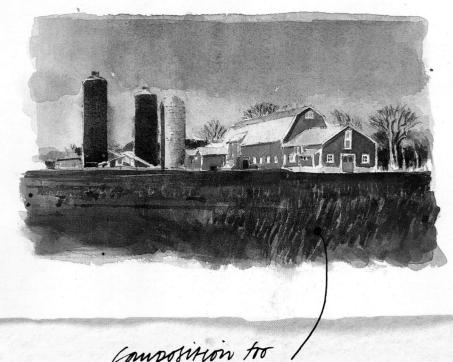

Composition to , every baranced

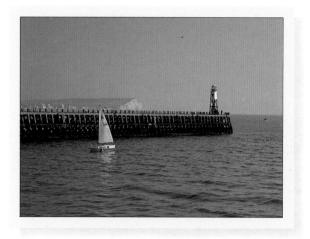

Seascape

AN ENGLISH HARBOR

ne would think that a seascape should be the easiest of all subjects to tackle – there are few elements to contend with and a single wash of color for the ocean and sky should suffice to produce a harmonious composition. In my experience, however, a seascape can be one of the most demanding of all subjects; precisely because there are few elements, it requires the most careful judgment and restraint.

Composition is critical – particularly the position of the horizon line, which can determine the emphasis given to sky or sea. Even on a cloudless day, the light and mood of a seascape can change rapidly. The underlying composition, therefore, needs to be firmly established. A low horizon in your composition would make the sky the key note of the whole painting. Conversely, a horizon line pitched high in your painting would lead one to concentrate on the ocean. If the horizon is placed equidistant between sea and sky, there needs to be some other element that offers contrast to the symmetry of the composition. Of course, the horizon might be lost by a sea mist or by the quality of light on a hazy summer's day.

Watercolor is eminently suited to the evocation of such atmospheric qualities. A series of washes are usually needed to render the vaporous atmosphere of a seascape convincingly – the tonal strength of the painting should be allowed to accrue by laying three or four pale washes over one another, rather than by trying to achieve the same effect with a single wash. The near-abstract qualities of the painting can be given added richness by careful tonal contrast.

The ocean has many moods, particularly in the northern hemisphere where in winter it can change from hour to hour. Not many artists, I suspect, would want to follow Turner's example by having themselves strapped to the mast of a ship in order to record directly a storm at sea!

Before starting a finished painting, you might find it useful to make some preliminary studies in your sketchbook. Look intently at the way that one wave folds over another on an incoming tide. Notice how patterns are created by the movement of the water itself and try different movements with your loaded brush to capture these qualities.

Artist * Ian Potts

CADMIUM ORANGE YELLOW OCHER

VIRIDIAN

Indigo

FRENCH ULTRAMARINE BLUE

COBALT

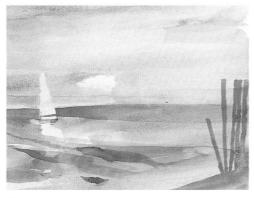

1 The artist has used the full page of a large sketchbook for this painting. Having first sponged the surface of the paper to soften the size content, he has applied a series of washes - some laid wet-in-wet, others allowed to dry before further layering. All the main features of the composition are in place at this stage - although everything is understated and atmospheric.

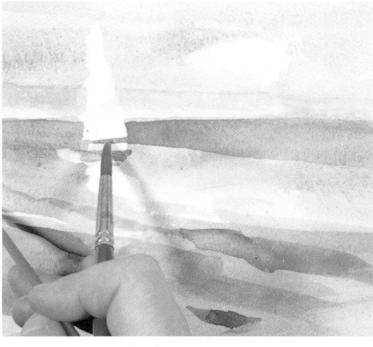

2 A fine sable brush and a broader flat brush are now used to define more sharply the folds in the waves.

Washes of green-blue, such as Viridian, contrast with red-blues, such as Ultramarine.

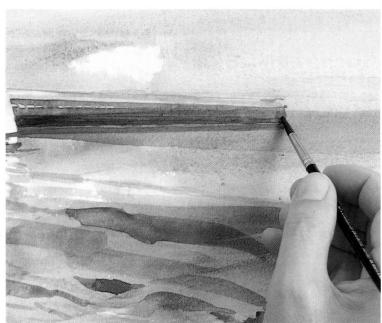

3 The wooden jetty is included at this stage, using a No. 8 sable.

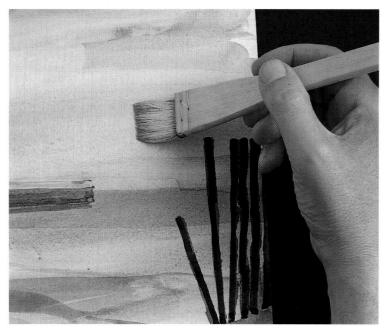

4 A wash of Cadmium Orange applied with a Hake brush provides a warm tone above the horizon.

Artist . Anthony Colbert

126

• A pale line drawing of the composition is traced down onto a sheet of Arches 300 gsm / 140 lb CP paper.

The cliffs, lighthouse, and sails are blotted out with masking fluid.

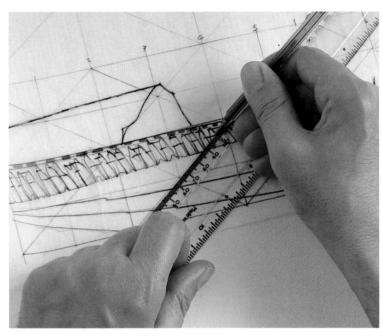

3 The rest of the sky area is lightly dampened and a pale wash of Cerulean Blue is laid with a Hake 3 inch brush. The wash is carried on below the horizon where the paper is dry.

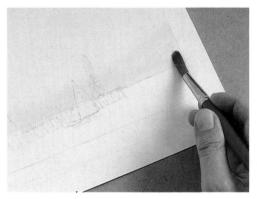

2 The paper is dampened with a Dalon 1½ inch brush just above the horizon. A generous wash of Burnt Sienna is laid from right to left with a Prolene 20 brush.

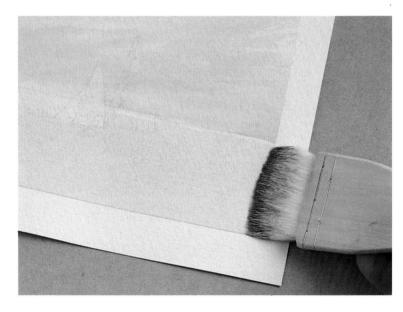

BURNT SIENNA

BURNT UMBER ALIZARIN CRIMSON

FRENCH
ULTRAMARINE BLUE

Indigo

CERULEAN BLUE

While the first wash is still wet, a second wash mixed from Ultramarine, Indigo and a touch of Alizarin Crimson is brushed upward from the headland, with a ³/₄ inch Hake. A cloudburst is established, as well as other cloud forms. A darker tone of Indigo reinforces the overhead raincloud and its shade in the foreground.

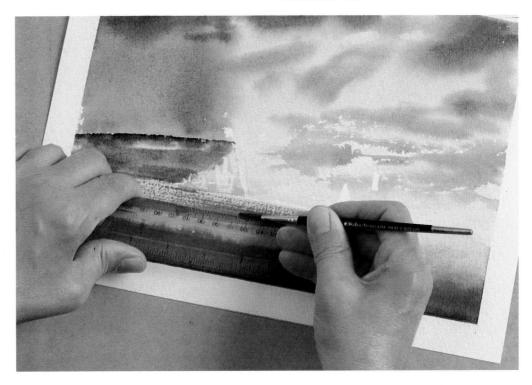

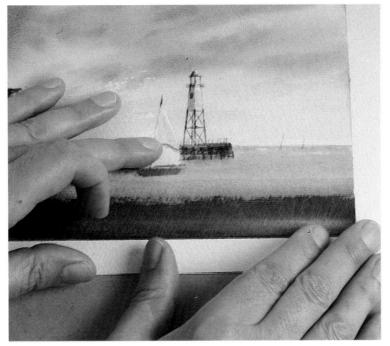

5 The same brush is rinsed to take up a mix of Burnt Sienna and Ultramarine for the shaded headland and grassland.

A similar mix of color is used for the pier, dragging the color from right to left with a No. 8 bristle. A ruler is used as a guide for the brush ferrule to produce a hard edge to the wash.

The masking fluid is removed. The structure of the pier is made more convincing with a darker monochromatic wash applied with a flat Dalon ½ inch. The same brush is used to paint the lighthouse structure. Finally, a touch of light orange complements the predominantly blue hue of the painting.

Artist • Deborah Jameson

128

• The first stage of the painting is carried out with a fine No. 3 sable brush loaded with a wash of Cobalt Blue.

The paper used is a Waterford rough surface.

2 A broader brush is used to mop up a copious supply of Cobalt mixed with Indigo and lay it down in one decisive action — allowing the white of the paper to show through on the cliffs, pier and boat.

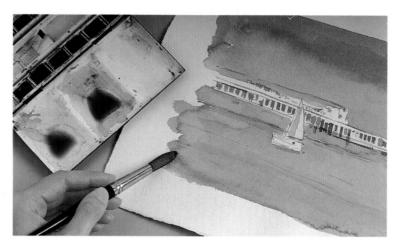

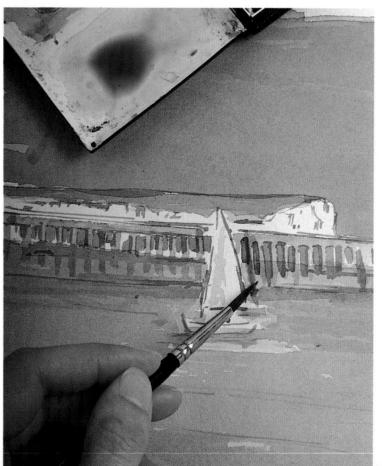

3 A second, more intense blue is overlaid when the first is dry. In addition, a neutral green (mixed from Yellow Ocher and Cerulean Blue) is applied to the distant landscape. The wooden structure of the pier is brushed in with Burnt Sienna.

YELLOW OCHER

PAYNE'S GRAY

COBALT

Indigo

ALIZARIN CRIMSON CERULEAN BLUE

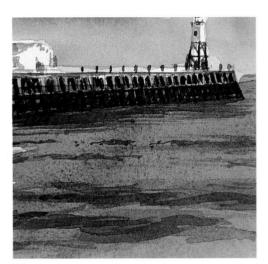

4 Two further washes of blue are overlaid at this stage - a Cerulean Blue influences the wash applied to the water.

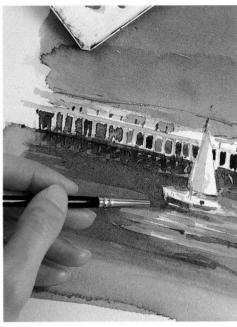

5 A touch of Alizarin Crimson is added to the hull of the sailing boat.

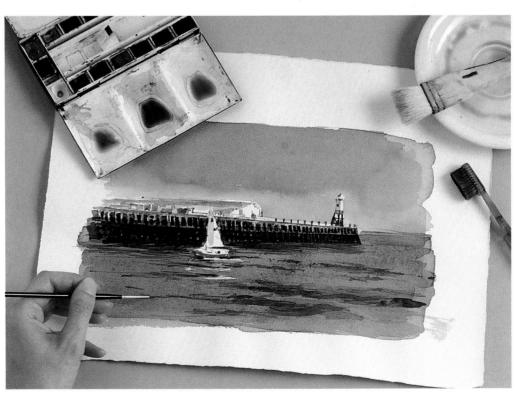

6 Most of the work in the final stage of the painting is concentrated on the structure of the pier and lighthouse. The folds in the waves are picked up with short, dry brushstrokes and some spatterwork is added. Undulating shadows are added to the waves with a medium sable and Indigo.

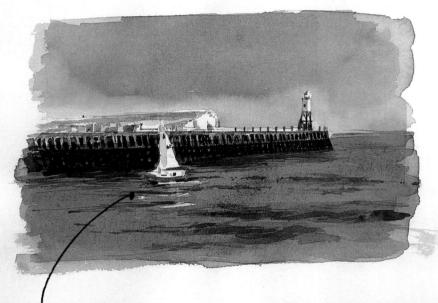

DEBORAH The long wooden jetty in this painting acts as a kind of balance in visual terms between the lighthouse and the yacht.

A change of scale might have benefited the composition – by painting the yacht larger, for instance.

The contrasting washes of warm and cool blues work well, as does the restrained use of color elsewhere in the painting.

getting nearer to the subject of a change of scale might have been of benefit to this painting

ANTHONY There is a sense of drama in this painting that is absent in the others. That is due in part to the treatment of the sky, which occupies three-quarters of the total area of the painting.

The yacht and lighthouse are placed roughly on a Golden Section ratio of 5:3 and that works well. You could argue that the treatment of the surface of the sea itself is perhaps too opaque – but, on the other hand, in chalkland regions the colors are often modified by the presence of chalk on the headland and on the seabed.

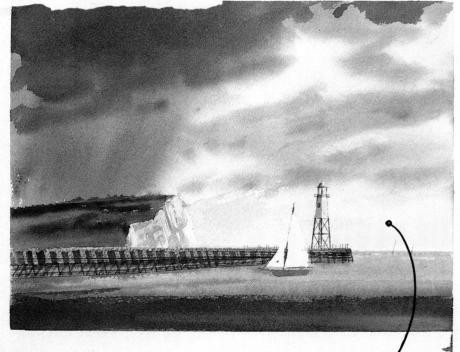

good some of drama in the handling of this painting

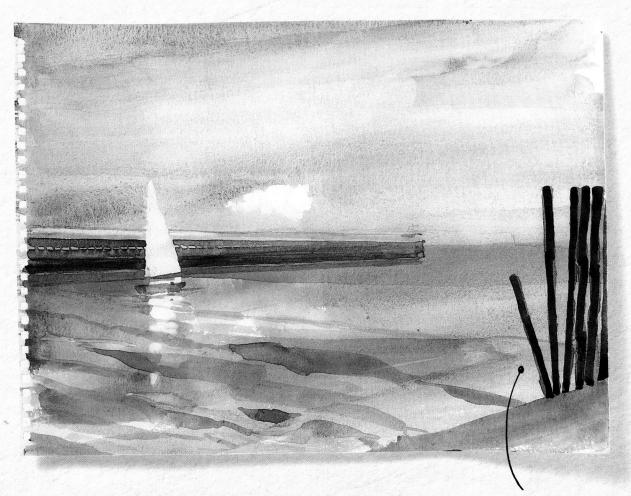

IAN The central part of this seascape composition works very well. The relationship of the single yacht to the horizontal harbor wall and the chalk cliffs emerging from the mist recall the seascapes of Turner.

The loosely painted wooden piles on the right-hand side of the composition, however, serve only to distract from the central core of the painting and do not contribute much to the composition as a whole.

Again, the color values are more akin to a southerly climate than to the northern hemisphere!

wooden piles distract from the cove of the composition

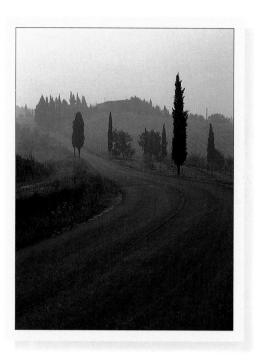

Change of Scene

ITALIAN LANDSCAPE

he traveling artist needs to take account of the fact that, in the process of searching for a suitable subject, he or she is likely to have to do a lot of walking and climbing to different levels. A certain amount of preparation beforehand can therefore help to ease the burden of carrying around too much cumbersome equipment. Everything needs to be kept to a minimum – a lightweight shoulderbag might contain a box of watercolors, pencils and brushes (in a protective tube), plastic waterpots (2), waterbottles, paper towels and a spiral-bound sketchbook or a variety of watercolor papers clipped to a supporting sheet of hardboard. Protective clothing is also necessary especially if you find it difficult to judge the weather pattern in another country. It is one thing to be walking around for a subject to paint but, having found it, you might be sitting still for two or three hours at a time. Climate has a bearing on everything and, in my experience, it is rare to find conditions that are perfect for painting. It may be too hot,

too cold, windy or wet and, having found your subject, you may have chosen the wrong time of day. In mountainous regions such as Switzerland, for instance, one side of the valley might be in shadow for most of the day.

The subject selected for this project is the gentle, undulating countryside of Tuscany in central Italy. It is a scene that represents the classical ideal in landscape painting and one that is relatively unchanged since the time of Simone Martini (c.1285–1344) and Piero della Francesca (c.1410/20–92). Cypress trees provide dark sentinels that punctuate the predominantly horizontal forms of this wine-growing area. The artists worked early in the morning, at that time of day when the mist has cleared and the sun has not yet risen above the hills. The whole scene is invested with a sense of mystery as buildings and distant forms are not clearly defined. The narrow road leads the eye from the foreground toward barely perceived farm buildings on a distant hill.

Artist • Ian Potts

NAPLES YELLOW

BURNT SIENNA ALIZARIN CRIMSON VANDYKE BROWN

HOOKER'S GREEN

COBALT FRENCH
ULTRAMARINE BLUE

1 A Bockingford spiral-bound sketchbook has been used vertically rather than horizontally to make the composition more interesting.

A much-diluted warm ocher-brown wash has been laid over the whole page with tissue and allowed to dry. Further colors have been applied wet-in-wet and merging from blue-gray on the horizon to purple-gray in the foreground. Details on the horizon have been added using a much finer sable brush.

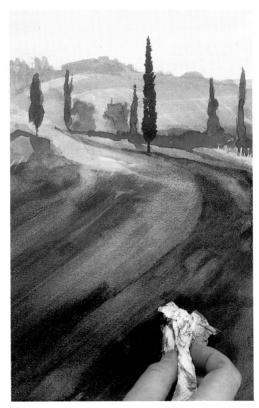

3 Tonal contrasts are further heightened with richer washes of the previous colors used. Color is applied with tissue to broader areas, such as the road surface, and with a No. 8 sable brush for more sharply defined forms such as trees, grass and shadows. The painting has now more depth tonally.

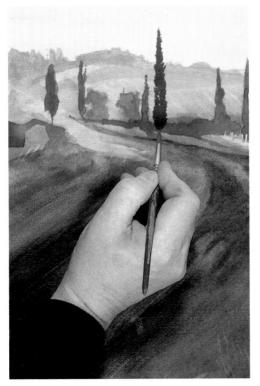

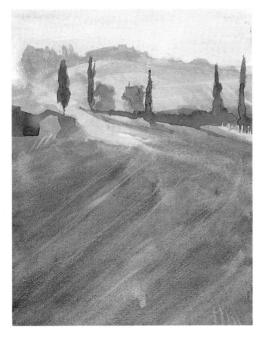

2 Tonal contrasts are now firmly established – a line of cypress trees in the middle-distance is painted in as the strongest tone with a mix of green-brown.

Colors in the foreground are intensified by a sequence of layered washes – mauve-gray made from Alizarin Crimson, Ultramarine and a touch of Burnt Sienna.

A blue-green wash made from Cerulean Blue and Hooker's Green is overlaid on the grass verges.

The darkest tone of the painting — a near black — is mixed from Alizarin Crimson, Vandyke Brown and Ultramarine. This is painted over the cypress trees in the middle-distance and on the road surface in the foreground. Those parts of the color that appear too heavy tonally are blotted off again while the color is still wet.

Artist . Anthony Colbert

• A base wash of Alizarin Crimson mixed with Raw Sienna covers the whole area. When dry, a second wash of the same mix follows the contours on the horizon and continues covering the middle-distance and foreground.

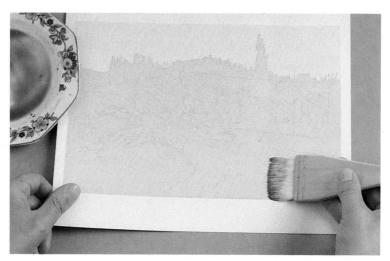

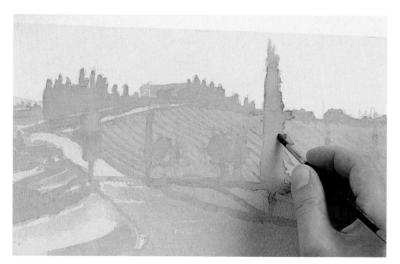

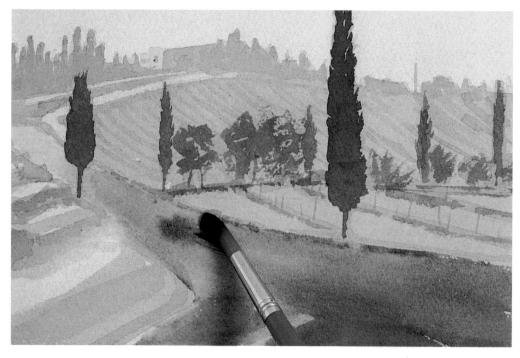

3 A stronger wash of Indigo with Yellow Ocher and Burnt Sienna is laid on trees and establishes shadows and furrows in the fields.

The paper is dampened and the track and verges are picked out with a wash of Indigo and Cobalt Blue. The same wash fades into the foreground of the road.

NAPLES YELLOW

YELLOW OCHER

BURNT SIENNA BURNT UMBER

Indigo

ALIZARIN CRIMSON PRUSSIAN BLACK

4 The color around the verge is lifted and softened to take a wash of Burnt Sienna. Trees in the middledistance are made darker. Flowers and stones in the foreground are masked out.

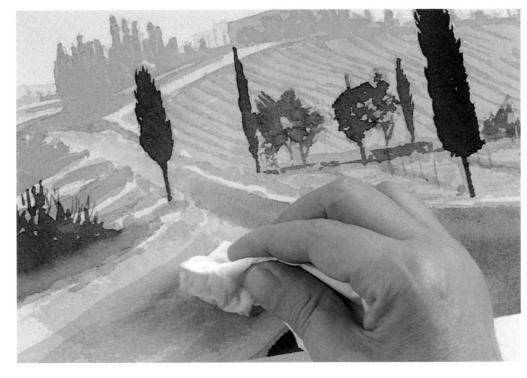

5 The dark cypress tree is brought up to full strength. Damp and dry brushstrokes are used in the foreground along the verge. Masking fluid is removed and flowers and stones painted in with Naples Yellow, Burnt Umber and Burnt Sienna.

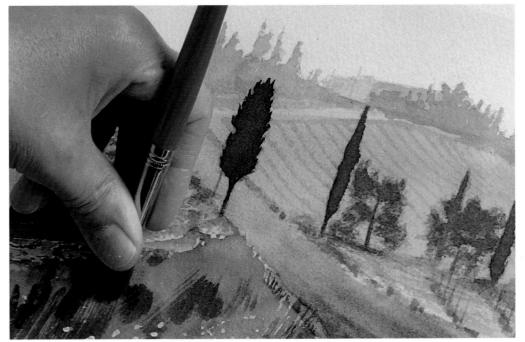

6 This detail shows how the bristles of a Prolene 20 brush are flayed between finger and thumb to drag color across scrubland.

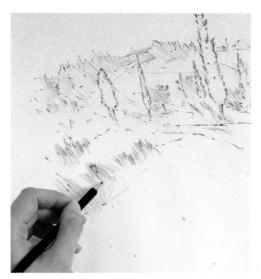

1 The main forms of the landscape are drawn with a soft pencil on a hot-pressed sheet of watercolor paper.

2 A warm wash mixed from Cadmium Orange and Naples Yellow is brushed over the whole area of the composition with a large Chinese brush.

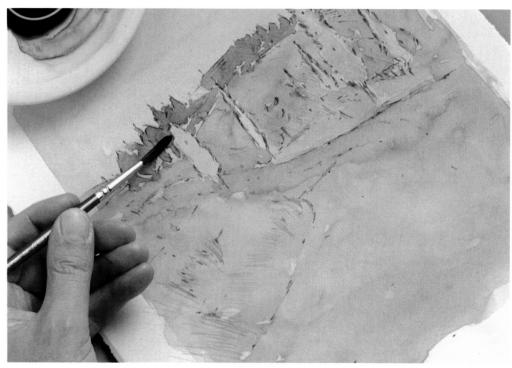

3 A wash of Payne's Gray is applied at this stage to produce an even tone that is without contrast.

NAPLES YELLOW

BURNT SIENNA

PAYNE'S GRAY CADMIUM ORANGE

FRENCH ULTRAMARINE BLUE

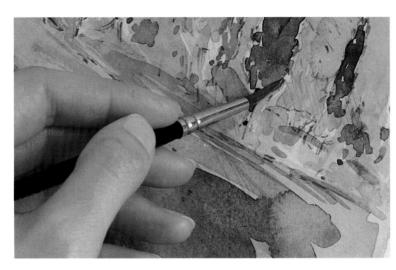

4 The landscape forms are heightened with a wash mixed from Burnt Sienna and Naples Yellow. A green-brown wash is also applied to the cypress trees in the middle-distance.

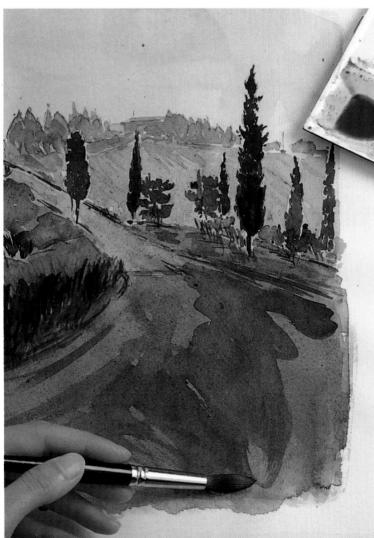

A rich, olive-colored wash is made from Payne's Gray, Yellow Ocher and Prussian Blue. This is used fairly solidly on the trees and as a wash on the landscape.

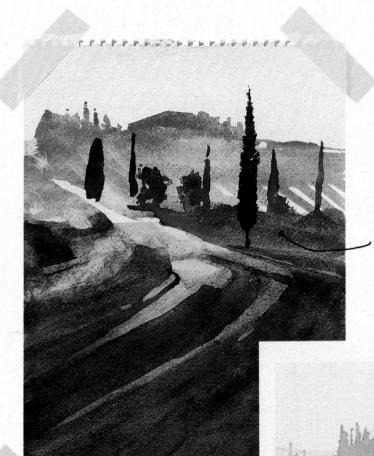

IAN The early stages of this painting revealed exquisite qualities of light – the radiance of which has been lost to some extent in the final painting.

One has the feeling that the artist felt constrained by the size of the paper on which he was working – his technique of laying on color in broad washes might perhaps have worked better on a larger format.

In purely abstract terms, this painting works very well – it is a bit like looking at a detail from a larger painting.

Radiance of light in early stages has been lost

- Good feeling for light

ANTHONY This painting demonstrates a mature handling of the medium – the quality of diffused sunlight is particularly effective. One has the impression of a heathaze in the distance – dust-laden, rather than dull and misty.

It is also a well-composed painting in which the cypress trees seem to punctuate the landscape at intervals that are critical to the visual balance of the painting.

Good Composition

Good tonal control

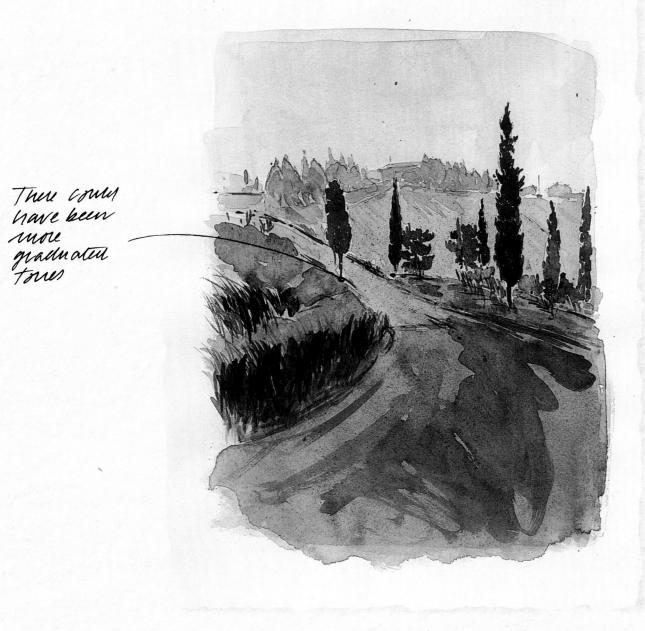

DEBORAH This painting also conveys a feeling of diffused sunlight, although the brushwork is more loosely handled.

The choice of a few washes that are closely related in tone and color works to advantage for this subject. There could have been even more graduation of tone from light to dark and from sky to foreground.

Glossary

140

ALLA PRIMA

Painting directly onto a support in a single session, without any preliminary underpainting or drawing.

AQUARELLE

Alternative generic name for watercolor. Also brand name for water-soluble colored pencils.

ATMOSPHERE

Relates to the suggested recession in a painting, achieved by changes in tone and color between the foreground and background.

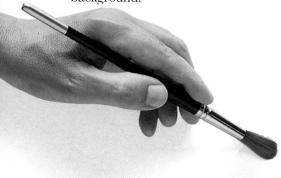

BLENDING

Merging colors together with a brush.

BODY COLOR

Essentially, white gouache. Can also refer to watercolor paint mixed with white gouache to make it opaque.

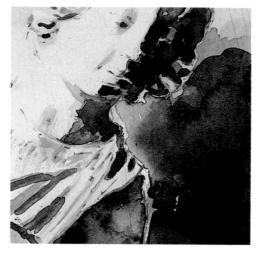

CALLIGRAPHIC

A term that refers to a cursive linear mark.

CHARCOAL

Sticks for drawing made from charred willow or vine twigs.

COMPLEMENTARY COLORS

Complementary colors are found opposite each other on the color wheel. A color is complementary to the color with which it contrasts most strongly, such as red with green.

COMPOSITION

The satisfactory disposition of all the related elements in a painting.

CROSS-HATCHING

A means of creating tone with a pen or pencil using layers of criss-cross parallel lines.

DRAWING IN

The initial statement of the drawing prior to painting.

DRY BRUSH

A technique in which excess water is squeezed out of the brush. This leaves a residue of dry pigment, which is then applied to the surface of the paper, creating a textured broken line.

FERRULE

The metal part of the brush that binds the hair to the wooden handle.

FILLER

Pigmentlike material usually white in color – e.g. chalk. Used in the manufacture of gouache.

FORM

A term that refers to the threedimensional appearance of a shape.

FUGITIVE

Used to describe colors that are liable to fade under strong light or in the course of time.

GOUACHE

An opaque watersoluble paint. Sometimes called body color.

GRAIN

Refers to the direction of the fibers in machine-made papers. Handmade papers have no directional grains. The different surface qualities of watercolor paper is determined by the texture of the felts through which it is pressed or "couched." Hot-pressed paper is additionally pressed through heated rollers to produce a smooth surface.

GRAPHITE

A form of carbon used in "lead" for pencil manufacture.

GUM ARABIC

In purest form, the sap produced by acacia trees; used as a binding medium in watercolors.

HALF-TONE

A tone mid-way between black and white, or the strength between the lightest and darkest tone.

HUE

The color, rather than the tone, of a pigment or object.

LOCAL COLOR

The actual color of an object, such as the red of an apple, rather than a color that is modified by light or shadow.

MEDIUM

The medium is (a) the type of material used to produce a drawing or painting e.g. charcoal, pastel, watercolor, oil, etc. or (b) a substance blended with paint to thicken, thin, or dry the paint.

MODELING

Expressing the volume and solidity of an object by light and shade.

MONOCHROME

Refers to a painting produced with a single color, gradations of color, or in black and white.

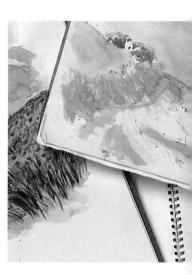

OPAQUE

Describes the density of paint. Not transparent.

PALETTE

A dish or tray on which colors are mixed – made from wood, metal or china. Also refers to the range of colors selected individually by the artist.

PERSPECTIVE

A means of recreating the illusion of three dimensions when painting on a two-dimensional surface. Linear perspective makes use of parallel lines that converge on a vanishing point. Aerial perspective suggests distance by the use of tone.

PICTURE PLANE

An imaginary transparent vertical screen between the artist and the subject. It is set at the distance from the artist where the drawing is intended to begin.

PIGMENT

The colored matter of paint originally derived from plants, animal, vegetable and mineral products. Generally synthesized chemically in paint manufacture.

RESIST

A term that refers to the use in watercolor painting of wax and masking fluid, which are both water resistant.

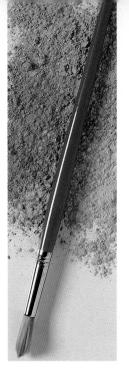

SIZE

A weak solution of any form of glue. In the manufacture of watercolor papers, a size is applied to impregnate the surface and control the degree of absorbency. The size usual for paper is traditionally made from gelatine with alum dissolved in alkalis.

SPATTER

A means of creating a texture of flecked particles of colored paint by dragging the bristles of the brush against the blunt edge of a knife.

SUPPORT

The surface on which the painting is made (canvas, wood, paper, etc.).

TONE

The light and dark value of a color; for example, pale red is the same tone as pale ocher but both are lighter in tone than dark brown.

WASH

Diluted watercolor applied to the surface of paper. Dries as a thin transparent film of color.

WATERCOLOR

Colored pigment bound in gum arabic, watersoluble.

WET-IN-WET

A watercolor technique that allows colors to merge randomly while still wet.

Index

Ackerman, Robert 18
Additives 22
Animals, cats 84-91
Apples 60-7
Aquarelle 140
pencils 21, 23, 140
Architecture,
parish church 100-7
townscape 108-15
Atmosphere 32, 124, 140

Blackadder, Elizabeth 84
Bonington, Richard Parks 25
Bonnard, Pierre 92
Brush holders 13, 27
Brushes,
Chinese 24-5, 38
choice 12-13, 24

Chinese 24-5, 38 choice 12-13, 24 drawing with 24, 38-41 hog's-hair 36, 38 maintenance 26-7 sable 12-13, 24-5, 38 synthetic 12, 24 toothbrush 21, 36, 118

Buildings, churches *37*, *52*, *100-7* red barns project *116-23* townscape *108-15*

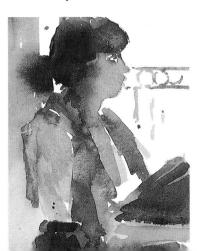

Calligraphy 23, 24, 38, 140
Candle wax 21, 36
Cats 84-91
Cézanne, Paul 8-9, 46, 48, 52, 60
Chairs 12
Chardin, Jean-Baptiste-Siméon 60
Chinese brushes 24-5, 38
Churches 37, 52, 100-7
Clothing 132
Colbert, Anthony 58

Cold-pressed paper 14
Coldstream, William 25
Colors,

choice 12-13, 18-19 mixing 48-9, 68 palette 59, 141 tone 47, 50-1 use 48-9

Composition 52-3, 58 interiors 92, 98 landscapes 100, 123 portraits 82 seascapes 52, 124, 131 still life 60

Constable, John *15*Contrast *68*, *123*Cotman, John Sell *28*, *42*, *48*Cozens, John *42*, *48*

Delacroix, Eugène 32, 52
Drawing,
with brushes 38-41
exercises 40-1
pencil and wash 42-3
pens 23
Dry brush technique 34-5, 140
Dürer, Albrecht 84

Easels 12
Equipment,
maintenance 26-7
portable 12, 132
Eye-level 54, 99

Felt-tipped pens 44
Francesca, Piero della 132
Fugitive colors 19, 140
Full-pans 18

Glazes 14, 20, 22 Glossary 140-2 Goethe, Johann Wolfgang von 58 Golden Section 53, 130 Gouache 20-1, 140, 141 Gum arabic 18, 22, 35, 141

Half-pans 12, 18 Hog's-hair brushes 36, 38 Hot-pressed paper 14

Inks 20-1

pen and wash technique 44-5

Interiors, farmhouse kitchen 92-9

Jameson, Deborah 58 John, Gwen 9, 84

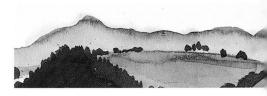

Landscapes, basic kit 13 brush drawing 41 composition 52-3, 100 Italy 132-9 layering techniques 46-7 pen and wash technique 44 red barns project 116-23 tone 50-1, 136-9 wet-in-wet technique 32-3 Layering techniques 46-7 Light 48, 50, 124, 138 antique head project 68-75 Line and wash technique 42-3, 58 Liquid paint 18

Maintaining equipment 26-7
Martini, Simone 132
Masking fluid 21, 36-7, 127, 135
Materials 10-55
basic kit 13
choosing 12-25
maintenance 26-7
portable 12, 132
Media 20-1
Mixed media 20-1

Mixing color 19, 48-9, 68

Index

144

Newton, Sir Isaac 48

Oudry, Jean-Baptiste 60 Overworking 75, 83 Oxgall liquid 22

0

Paintboxes, choice 12, 18 maintenance 27

Paints,

additives 22 choice 12-13, 18-19

Palettes 141 choice 12, 13, 18 maintenance 27

Palmer, Samuel 44

Papers,

choice 12, 14-17 cotton 42

pencil and wash technique 42 sizing 14, 22

stretching 14, 29

textured 14, 17, 23, 34

weight 12, 14, 29

Pen and wash technique 44-5 Pencil and wash technique

42-3, 58

Pencils,

choice 13, 23
pencil and wash technique 43
water-soluble 21, 23, 140

Pens,

choice 23
felt-tipped 44
pen and wash technique 44-5
Perspective 54-5, 142
Picture plane 55, 142
Pigment 18-19, 20, 28, 50, 142

bamboo 21, 23

Piper, John 20 Portraits,

brush drawing 41 girl reading 76-83

Potts, Ian 58 Poussin, Nicolas 52

Projects 56-139

approach 58-9 architecture,

parish church 100-7 townscape 108-15

cats 84-91

interior,

farmhouse kitchen 92-9

landscapes,

Italy *132-9* red barns *116-23*

light and shadow,

antique head 68-75

portraits, girl reading 76-83 seascape, an English harbor

124-31

still life, three apples 60-7

B

Reflections 95
Rembrandt 76
Resist technique 20, 36-7, 142
Rice starch 22
Rough paper 14, 34

8

Sable brushes 24-5
Seascapes 52
an English harbor 124-31
Shadow 51, 63-6, 96-7
antique head project 68-75
Sickert, Walter 48
Sizing 14, 142
prepared size 22
Sketchbooks 13, 15
Spatter technique 21, 36-7, 118, 142
Still life, Three Apples 60-7

Stretching paper 14, 29

Techniques 10-55, 56

Tempera paints 20
Texture 20
dry brush technique 34-5
paper 14, 17, 23, 34
resist technique 36-7
Tinted paper 14-17
Tone 47, 50-1, 68, 98, 113-14, 142
landscapes 50-1, 136-9
Turner, J.M.W. 8, 18, 28, 42, 48,

van Gogh, Vincent 92 Varnish 22 Vermeer, Jan 92 Viewing device 53, 92

Washes 28-37, 142 brush drawing 41 brushes 24-5 dry brush technique 34-5 graduated 31 layering techniques 46-7 laying 30-1 mixing 28 pen and wash technique 44-5 pencil and wash technique 42-3 washing out 30 wet-in-wet 22, 32-3, 142 Water, seascapes 124 Water-soluble pencils 21, 23, 140 Wax, candles 21, 36 pencils 20

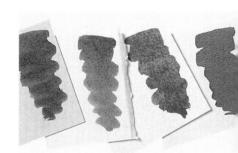

Wet-in-wet technique 22, 32-3, 142

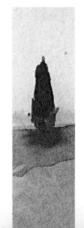